Collecting Early Machine-made Marbles

The M. F. Christensen & Son Company
and Christensen Agate Company

Robert S. Block

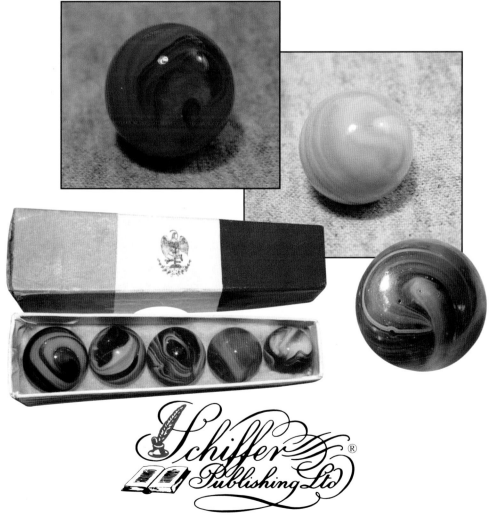

Schiffer Publishing Ltd

4880 Lower Valley Road, Atglen, PA 19310 USA

Dedication

This book is dedicated to all marble collectors and marble historians who are constantly striving to advance the knowledge of marble collecting.

Acknowledgments

No author writes their book in isolation. Thanks first to all those who graciously allowed me to photograph their marbles for this book. A special thanks to the following people:

Hansel de Sousa, who early on recognized the unique place in marble history of Transitionals, M.F. Christensen, and Christensen Agate marbles. He sought to preserve unique examples of them and their packaging.

Charley Hix, Jr., who has long been a booster of Transitional marbles and allowed me to photograph his extensive collection.

Bill Tow, who you could only describe as a Christensen Agate Company cheerleader. He provided numerous examples of his marbles and those of other collectors for this book.

Peter Sharrer, for allowing me to use several rare items of his in this book.

Brian Graham and his associates, whose pioneering archeological site work and documentary research of various Ohio marble companies has greatly increased the knowledge of early marble making in America.

Stanley Block and the Marble Collectors Society of America for access to their vast collections and to the MCSA archives.

Mark Block, for editing an early version of this manuscript.

My wife, Sarah, for her hours of uncomplaining support while I wrote this book.

And Peter Schiffer and his staff for their tireless work in producing this book.

All images by author except as noted.

Library of Congress Cataloging-in-Publication Data

Block, Robert.
 Collecting early machine-made marbles: the M. F.
Christensen & Son Company and Christensen Agate
Company / by Robert S. Block.
 p. cm.
 ISBN 0-7643-1827-6
1. Marbles (Game)--Collectors and collecting. 2.
Christensen Agate Company. I. Title.
NK6215 .B575 2003
796.2--dc21

 2003012449

Designed by Mark David Bowyer
Type set in Korinna BT/Humanist 521 BT

ISBN: 0-7643-1827-6
Printed in China
1 2 3 4

Published by Schiffer Publishing Ltd.
4880 Lower Valley Road
Atglen, PA 19310
Phone: (610) 593-1777; Fax: (610) 593-2002
E-mail: Info@schifferbooks.com
Please visit our web site catalog at
www.schifferbooks.com
We are always looking for people to write books on new and related subjects. If you have an idea for a book please contact us at the above address.

This book may be purchased from the publisher.
Include $3.95 for shipping.
Please try your bookstore first.
You may write for a free catalog.

In Europe, Schiffer books are distributed by
Bushwood Books
6 Marksbury Ave.
Kew Gardens
Surrey TW9 4JF England
Phone: 44 (0)20-8392-8585
Fax: 44 (0)20-8392-9876
E-mail: Bushwd@aol.com
Free postage in the UK. Europe: air mail at cost

Contents

Introduction

Early American companies revolutionized the marble industry. Through the mid- to late 1800s, almost all glass marbles were produced in Germany and exported from there. The American glass marble making industry was virtually non-existent with only a couple of companies producing a very few marbles. Companies making marbles out of clay (for instance, the S.C. Dyke & Company, and The American Marble and Toy Manufacturing Company, both in Akron, Ohio) were much more common; however, clays were considered inferior to glass and agate marbles.

German techniques could produce a relatively large number of marbles a day, making it difficult for American companies to compete. During the 1880s, and on into the turn of the following century, American companies began producing "Transitional" marbles. These were a slag type, similar to a type also produced in Germany, and were cheaper to make than German swirls. While many are beautiful in their own right, they can't match the bright colors and patterns of German handmade swirls. However, they were much less expensive to produce than German handmade marbles, so they did allow American companies to compete with the German companies.

In the early 1900s, Martin F. Christensen developed a machine that revolutionized marble production. Rather than rounding marbles by hand, he created a machine that could perform the task of rounding the glass into a sphere. Later, Christensen developed a technique that allowed a number of marble machines to be controlled simultaneously, essentially introducing mechanized mass production techniques to marble making.

Martin Christensen's revolutionary machine changed the economics of marble making. American companies could now compete with German companies by producing a less expensive glass marble. In the early 1920s other American companies (Akro Agate and Peltier Glass) began producing marbles using machinery similar to Christensen's.

Research in Germany has shown that handmade marble production continued well after the end of World War One. Most American marbles produced during this period of time were slag, designed to imitate agate. They lacked the color and eye-appealing design of German marbles. As a result, German handmade marbles were still popular with children and American companies still found it difficult to compete with German makers.

This began to change in the mid-1920s. Both Akro Agate and Peltier Glass began to introduce more innovative designs, diversifying away from slags and into the patch, spiral, and sparkler styles. However, it was another company, Christensen Agate Company, which revolutionized the palette and design of American marbles. Utilizing proprietary glass formulae, Christensen Agate Company produced a dazzling array of eye-appealing colors and designs that captured the imagination of marble players (and later, collectors).

These innovations by Akro, Peltier, and Christensen Agate, further revolutionized the industry and eventually superseded German industry hegemony.

Akro Agate Company and Peltier Glass Company will be covered in the next book in this series. These two companies were able to turn their innovations to their advantage and survive the competition. This book focuses on M.F. Christensen & Son Company and Christensen Agate Company (as well as the earlier Transitionals). While these companies paved the way for American domination in marble production, they could not survive their own revolution.

Marble Collectors Society of America

The Marble Collectors Society of America was founded in 1975 as a non-profit organization established for charitable, scientific, literary, and educational purposes. The Society's objectives are to gather and disseminate information and perform services to further the hobby of marbles, marble collecting, and the preservation of the history of marbles and marble making. The Society currently has over 2,000 contributors.

Society projects include the quarterly newsletter, *Marble Mania*, color marble photograph plates, a videotape series, and contributor's listings. In addition, we are in the process of ongoing research, and the development of a collection of marbles for the Society library, which will be available on a loan basis to libraries and museums.

Other major accomplishments of the Society to date are the uninterrupted issuance of a quarterly newsletter, *Marble Mania*; various surveys; photographing and publishing color sheets; gathering and placing collections in museums (The Smithsonian, The Corning Museum of Glass, and the Wheaton Village Museum); publication of price guides, with periodic updates; work toward establishing a library of articles and marble related materials; preparation of slide presentations; preparation and publication of contributor listings; research and issuance of articles concerning marble factories and contemporary marble makers; publication of Mark Randall's booklet, *Marbles as Historical Artifacts*; preparation of videotapes on marbles, including the first two-hour videotape on collecting marbles; classification and appraisal services; as well as the books *Marble Mania*, and Robert Block's *Marbles: Identification and Price Guide*. In addition to the above, the Society is working on additional tabletop books covering all facets of the hobby of marbles. These books will expand on the book *Marble Mania* that was published in 1998.

Each book will be a photographic manual, covering a specific section of the hobby, and each book is planned to contain over 500 photographs. The first of these expanded books, *Contemporary Marbles and Related Art Glass*, by Mark Block, was published in January 2001. It contains over 800 photographs representing well over 100 glass artisans.

The next book published, *Sulphide Marbles*, was authored by Stanley Block and M. Edwin Payne, with an Introduction by Robert Block and was published in May 2001. The hardcover book, *Sulphide Marbles*, contains over 600 photographs and is the first of three books covering antique handmade glass marbles. The series was continued by Antique Glass Swirl Marbles by Stanley Block, published in 2001 and Antique End of Day Marbles by Stanley Block, published in 2003. This book begins the machine made part of the series.

Our next book is planned to be the second of those covering machine-made marbles.

Transitional

The term "Transitional" is applied to all slag marbles that are handgathered and have a single pontil. The term was first published in Castle and Peterson's *Collectible Machine-Made Marbles* describing marbles that were surmised to have been gathered by hand and then formed by machine, hence the "transition" between hand-made and machine made marbles. Subsequently, research has uncovered evidence that regular pontil and ground pontil "transitionals" were produced as early as the 1850s in Germany. At the other end of the timeline, some crease pontil "transitionals" were probably produced in the Far East as late as the 1950s. We now recognize that there is an entire spectrum of slags with pontils or pontil-type marks: Those made completely by hand, those gathered by hand and dripped into a machine, and those made completely by machine.

Early American attempts to mimic German handmade marbles met with limited success, the most notable being the S. C. Dyke & Company, The American Marble and Toy Manufacturing Comapny, and Iowa City Flint Glass Manufacturing Company. American marbles were more expensive to produce than German marbles, an alternative had to be found, and "slag" marbles provided the answer. Rather than spending the time creating perfectly constructed canes for swirl and end of day type marbles, a single batch of glass was prepared from which a "charge" or glob of molten glass could be gathered on a rod and then formed into a marble. These single-gather marbles would have only one pontil, where they were cut off the rod.

The creation of marble making machinery created two distinct advantages for American marble manufacturers. First, the mechanization of the process to form the glob of glass into a sphere increased production. Second, machinery had the potential to form the glass into more perfect spheres or make them rounder, than hand methods. Later improvements created a mechanized feed system so that the glass did not have to be gathered by hand. Prior to Akro Agate's Early Improvement, and similar innovations by other companies, the spot where the marble's glass was sheared off the stream would sometimes survive the rounding process, especially if the glass was too cold when it entered the machinery.

Pontil Types

Transitional marbles are usually identified by pontil type, although some can be identified by the specific company.

Regular pontil — The marble was cut off the gathering rod and the resulting pontil was not altered. This is similar to the pontil marks found on handmade marbles, which have not been faceted or melted. These marbles were produced in both Germany and probably the United States. There is a small group of pontiled slags which were acquired in China. Research has not determined if these were made in China by an indigenous industry, by German immigrants, or were imported there. They do not look like traditional German or American pontilled slags, but are smaller and poorly formed.

Ground pontil — The pontil was ground down, using a grinding wheel. This can range from very fine facets to a single, roughly ground mark, depending on how long the marble finisher spent on the marble. These marbles were produced in both Germany and the United States.

Melted pontil — James Harvey Leighton patented a device in 1890 for removing the pontil from handmade handgathered marbles. The pontil was melted by a torch, and then smoothed using a hollow-shaped spike. Occasionally, you will find carboning around the pontil, if the flame was too cold or the gas used was too dirty. These marbles were produced almost exclusively in the United States.

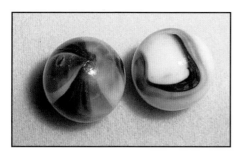

Melted Pontil Slag (top & bottom views), 3/4".
Acquired in Germany. Estimate of value: $75 to
$150. *Courtesy of Bert Cohen.*

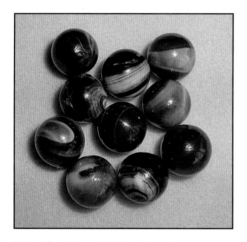

Melted Pontil Slags, 23/23". Acquired in
Germany. Estimate of value: $30 to $60.
Courtesy of Bert Cohen.

Pinpoint pontil — The pontil on these marbles
is characterized by a very tiny pontil that
looks almost like the head of a pin. Marbles
with this type of mark were machine made,
not single gathered and formed by hand.
The pontil on these marbles formed be-
cause the glass was a little too cool when it
was sheared as it dripped off the gathering
rod into the machine or as it came down
the automatic stream. As a result, the cut-
off spot did not completely melt into the
marble because the marble cooled too
quickly as it was forming. These pontils are
very rare. They are found only on Ameri-
can marbles.

Fold pontil — This pontil is characterized by a
tiny finger of glass that is folded over at the
cut-off point and partially melted into the
marble surface. Marbles with this type of
mark were machine made, not single gath-
ered and formed by hand. The pontil on
these marbles formed because the glass
was a little too cool as it came down the
automatic stream and was sheared into the
machine. As a result, the cut-off spot did
not completely melt into the marble be-
cause the marble cooled too quickly as it
was forming. These pontils are hard to find.
They are only found on American marbles.

Pinch pontil — This pontil is a straight crease at
the bottom of the marble. It can be either
long or short. Marbles with this type of
mark were machine made, not single gath-
ered and formed by hand. The pontil on
these marbles formed because the glass
was a little too cool when it was sheared
as it dripped off the gathering rod into the
machine, or as it came down the automatic
stream and was sheared into the machine.
As a result, the cut-off spot did not com-
pletely melt into the marble because the
marble cooled too quickly as it was form-
ing. It is generally believed that these are
American marbles. The longer pinch marks
seem to be found on duller colored slags;
M. F. Christensen & Son Company, and early
Akro Agate Company. The short pinch
marks are usually found on smaller, more
brightly colored handgathered marbles
(usually bright orange and white, or bright
red and white). The manufacturer of these
marbles has not been identified, although
some collectors feel the colors bear strong
resemblance to those of Christensen Ag-
ate Company.

Crease pontil — This pontil is similar to the pinch
pontil, but the mark is usually wavy, not
straight, and has a web-like or crinkly look
to it. Marbles with this type of mark were
machine made, not single gathered and
formed by hand. The pontil on these
marbles formed because the glass was a
little too cool when it was sheared as it
dripped off the gathering rod into the ma-
chine, or as it came down the automatic
stream and was sheared into the machine.
As a result, the cut-off spot did not com-
pletely melt into the marble because the
marble cooled too quickly as it was form-
ing. Some of these are probably American
but most are foreign (Germany and the Far

East). In some cases, most of the crease has been ground off.

Bullet mold pontil — This pontil is a ground flat spot with a seam line starting at one end of it, running over the top of the marble, and ending at the opposite side of the pontil. These are the marbles commonly found in Codd bottles (marble stopper bottles). They are produced in a mold, not from a gathering rod. These were produced in England from the 1890s until about the 1950s, and they were also produced in Germany during the first quarter of the twentieth century.

Regular Pontil Slag (bottom view), 7/8". Acquired in Germany. Estimate of value: $75 to $150. *Courtesy of Bert Cohen.*

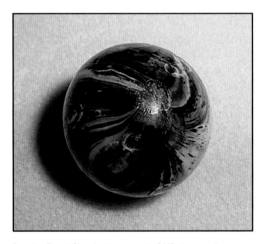

Regular Pontil Slag (bottom view), 3/4". Acquired in Germany. Estimate of value: $60 to $120. *Courtesy of Bert Cohen.*

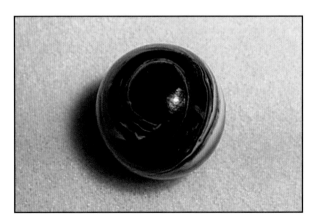

Regular Pontil Slag (top view), 7/8". Acquired in Germany. Estimate of value: $75 to $150. *Courtesy of Bert Cohen.*

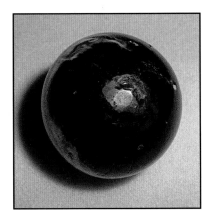

German. Ground Pontil Slag (bottom view), 1-1/16". Estimate of value: $150 to $300. *Courtesy of Bert Cohen.*

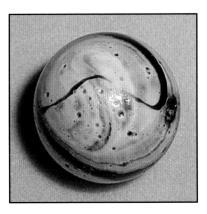

Ground Pontil Slag (top view), 1-1/16". Acquired in Germany. Estimate of value: $150 to $300. *Courtesy of Bert Cohen.*

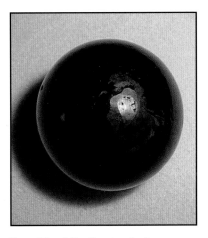

Ground Pontil Slag (bottom view), 1-1/8". Acquired in Germany. Estimate of value: $150 to $300. *Courtesy of Bert Cohen.*

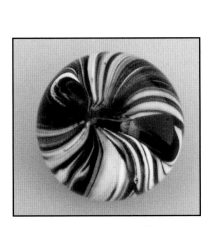

Transitional. Regular pontil, 1-1/4". Origin unknown. Estimate of value: $150 to $300. *Courtesy of Stanley Block.*

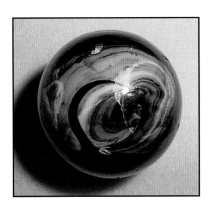

Ground Pontil Slag (top view), 1-1/8". Acquired in Germany. Estimate of value: $150 to $300. *Courtesy of Bert Cohen.*

S.C. Dyke and Company

S.C. Dyke and Company operated in Akron, Ohio, from about 1888 until 1892. The company founder, Samuel C. Dyke, is credited with being the first to mass-produce clay marbles in the United States (the Akron Toy Company, 1884). By 1890, competition in the clay marble market had reached the point that Samuel Dyke made the decision to begin producing handmade glass marbles. He hired an American glass worker, James Harvey Leighton, to help him start producing glass marbles. The company produced single gather, single-pontil slags. The base glass is transparent light green or transparent light amber, with a white hand-gather swirl.

American Marble and Toy Manufacturing Company

The American Marble and Toy Manufacturing Company operated in Akron, Ohio, from 1891 to 1904. It was founded by Samuel C. Dyke, and several other gentlemen from Akron. The company produced clay and pottery marbles and toys, as well as single-gather, single-pontil slags. It has also been reported that the company produced cane-cut glass marbles (including banded opaques and clambroths), chinas, and porcelains. The base glass is transparent light green or transparent light amber, with a white hand-gather swirl.

James Harvey Leighton

James Harvey Leighton was a glassworker who produced marbles in the Midwest and Ohio from the 1880s to the early 1900s. He came from a family of glassworkers and operated a number of small glass companies during that period of time. He has been associated with a number of marble companies, including J. H. Leighton & Company, S. C. Dyke and Company, Navarre Glass Marble and Specialty Company, M. F. Christensen and Son Company, and Barberton Glass Novelty and Specialty Company. It has also been reported that he assisted marble companies in Illinois and West Virginia. Leighton received a patent (#462,085) for the manufacture of "solid glass spheres" in 1891. Some researchers have referred to him as "The father of the American glass marble." Virtually all marbles made by James Harvey Leighton, or under his direction, have melted pontils. This was an integral part of his patent. However, because he used substantially the same production techniques and the same glass formulae at every company where he worked, it is impossible to ascertain the exact production location of most of his marbles, unless it was found in situ.

"Leighton" Transitionals

The term "Leighton" Transitional has been generically applied to single-pontil handgathered marbles that have a ground pontil and a distinctive "9" pattern to the swirl. The "9" pattern refers to the shape of the swirl of color on the base glass when the marble is viewed from the top (the end opposite the pontil). The colors on many are quite dramatic. Usually the transparent or translucent base color is clear, blue, green or white. The swirl can be any of a variety of colors including whites, yellows (some electric), greens, pinks, lavenders, and oxblood. However, some examples have been found with various other colors, including ground pontil transitionals that are an oxblood base with some white and/or clear mixed in.

All ground pontil transitional marbles with this type of pattern and these colors have been generically called "Leighton" Transitionals by collectors for the past decade. Research has shown that this type of marble was produced in Lauscha, Germany. Researchers have identified Elias Greiner and Septimius Greiner as the owners of the factory where these marbles were produced. Production is said to have begun in 1850. It is evident from this research and other anecdotal evidence, that "Leighton" Transitionals are in fact German and not American. This type of marble was probably produced into the early 1900s.

Navarre Glass Marble and Specialty Company

The Navarre Glass Marble and Specialty Company operated in Navarre, Ohio, from about 1897 to 1901. It was founded by James Harvey Leighton. The company produced single gather, single-pontil slags. Usually the base glass is purple, but green, clear, and amber were also used. The marbles have melted pontils.

Barberton Glass Novelty and Specialty Company

Barberton Glass Novelty and Specialty Company operated in Barberton, Ohio, from 1906 to 1908. It was started by James Harvey Leighton and some former Navarre Glass employees. The company produced single-gather slags. In order to differentiate their marbles from those produced by M. F. Christensen, the company turned to more exotic colors including aventurine green, pink, and lime-green. The factory burned in April 1908 and was not rebuilt. The company produced single gather, single-pontil slags. The base glass is transparent green, transparent purple or transparent light amber, with a white hand-gather swirl.

M.F. Christensen and Son Company

The M.F. Christensen & Son Company began producing marbles in 1905. The history of the company is developed in more detail later in this book.

Christensen hired, as their glass master, Harry Heinzelman who had formerly worked at Navarre Glass Marble and Specialty Company.

James Harvey Leighton acted as a consultant to Christensen, providing glass formulae.

M.F. Christensen marbles were handgathered. Many of these exhibit a shearing marble that is identified by collectors as a long pinch pontil. Some early M.F. Christensen marbles probably exhibit a melted pontil. However, these would be similar to other James Harvey Leighton marbles, so it would be difficult to attribute them to the M.F. Christensen and Son Company.

Christensen Agate Company

Christensen Agate Company began producing marbles in 1925. The history of the company is developed in more detail later in this book. Many early Christensen Agate Company slags and American Agates exhibit a hand-gather pattern. There are some small ground pontil slags that are electric colors, leading to speculation that these are Christensen Agate Company "transitionals." These have not been found in original packaging, so it remains speculation.

There has also been speculation that some of the pinch pontil transitions were made at Christensen Agate Company. This is supported by the fact that the red in many of them is very similar to American Agates.

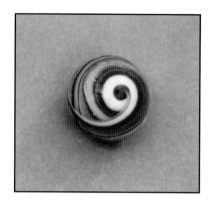

Transitional. Ground pontil, 15/16". Estimate of value: $1,500 to $2,500. *Courtesy of Jeff Yale.*

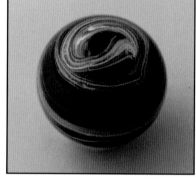

Transitional. Ground pontil, 13/16". Estimate of value: $500 to $1,000. *Courtesy of Anonymous.*

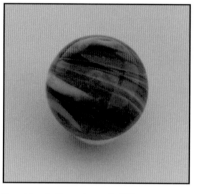

Transitional. Ground pontil, 7/8". Estimate of value: $500 to $1,000. *Courtesy of Peter Sharrer.*

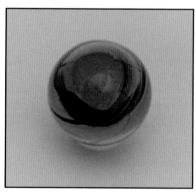

Transitional. Ground pontil, 7/8". Estimate of value: $500 to $1,000. *Courtesy of Peter Sharrer.*

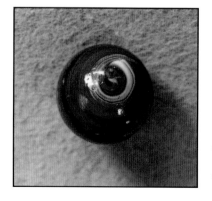

Transitional. Ground pontil, 13/16". Estimate of value: $500 to $1,000. *Courtesy of Charley Hix, Jr.*

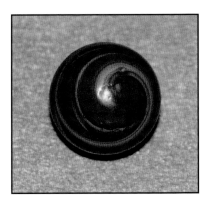

Transitional. Ground pontil, 29/32". Estimate of value: $500 to $1,000. *Courtesy of Charley Hix, Jr.*

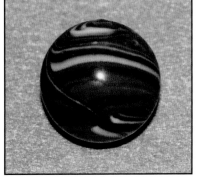

Transitional. Ground pontil, 27/32". Estimate of value: $500 to $1,000. *Courtesy of Charley Hix, Jr.*

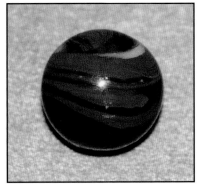

Transitional. Ground pontil, 13/16". Estimate of value: $500 to $1,000. *Courtesy of Charley Hix, Jr.*

Transitional. Ground pontil, 25/32". Estimate of value: $500 to $1,000. *Courtesy of Charley Hix, Jr.*

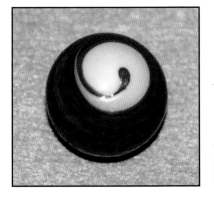

Transitional. Ground pontil, 13/16". Estimate of value: $500 to $1,000. *Courtesy of Charley Hix, Jr.*

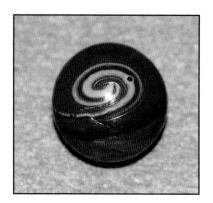

Transitional. Ground pontil, 27/32". Estimate of value: $500 to $1,000. *Courtesy of Charley Hix, Jr.*

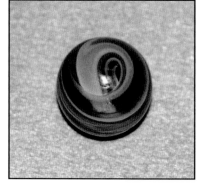

Transitional. Ground pontil, 25/32". Estimate of value: $500 to $1,000. *Courtesy of Charley Hix, Jr.*

Transitional. Ground pontil, 31/32". Estimate of value: $500 to $1,000. *Courtesy of Charley Hix, Jr.*

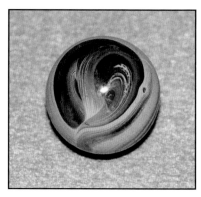

Transitional. Ground pontil, 29/32". Estimate of value: $500 to $1,000. *Courtesy of Charley Hix, Jr.*

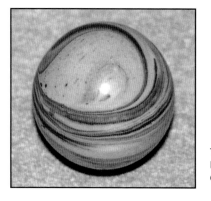

Transitional. Ground pontil, 1-11/16". Estimate of value: $2,000 to $4,000. *Courtesy of Charley Hix, Jr.*

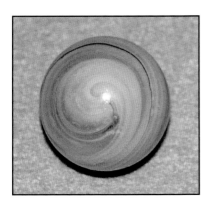

Transitional. Ground pontil, 31/32". Estimate of value: $750 to $1,500. *Courtesy of Charley Hix, Jr.*

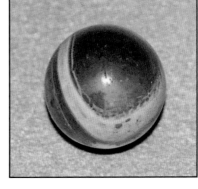

Transitional. Ground pontil, 1".
Estimate of value: $1,000 to $2,000.
Courtesy of Charley Hix, Jr.

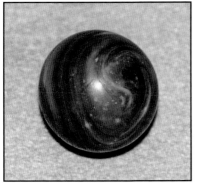

Transitional. Ground pontil, 13/16".
Estimate of value: $500 to $1,000.
Courtesy of Charley Hix, Jr.

Transitional. Ground pontil, 23/32".
Estimate of value: $400 to $800.
Courtesy of Charley Hix, Jr.

Transitional. Ground pontil, 11/16".
Estimate of value: $300 to $600.
Courtesy of Charley Hix, Jr.

Transitional. Ground pontil, 11/16". Estimate of value: $300 to $600. *Courtesy of Charley Hix, Jr.*

Transitional. Ground pontil, 11/16". Estimate of value: $300 to $600. *Courtesy of Charley Hix, Jr.*

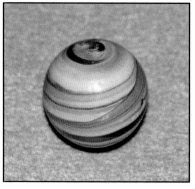

Transitional. Ground pontil, 11/16". Estimate of value: $300 to $600. *Courtesy of Charley Hix, Jr.*

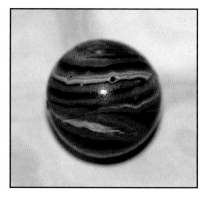

Transitional. Ground pontil, 13/16". Estimate of value: $400 to $800. *Courtesy of Elliot Pincus.*

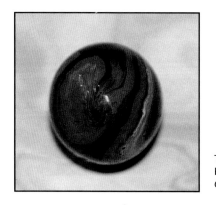

Transitional. Ground pontil, 13/16". Estimate of value: $400 to $800. *Courtesy of Elliot Pincus.*

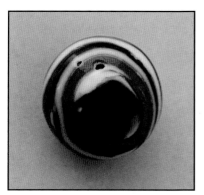

Transitional. Ground pontil, 7/8". Estimate of value: $500 to $1,000. *Courtesy of Hansel de Sousa.*

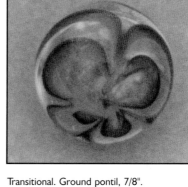

Transitional. Ground pontil, 7/8". Estimate of value: $1,750 to $3,000. *Courtesy of Elliot Pincus.*

Transitional. Ground pontil, 7/8". Estimate of value: $500 to $1,000. *Courtesy of Elliot Pincus.*

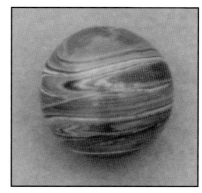

Transitional. Ground pontil, 7/8". Estimate of value: $500 to $1,000. *Courtesy of Elliot Pincus.*

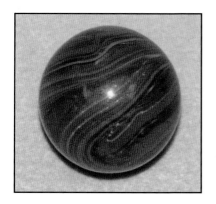

Transitional. Ground pontil, 7/8". Estimate of value: $500 to $1,000. *Courtesy of Stanley Block.*

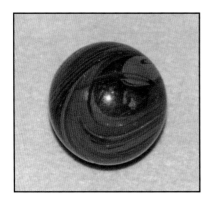

Transitional. Ground pontil, 7/8". Estimate of value: $500 to $1,000. *Courtesy of Stanley Block.*

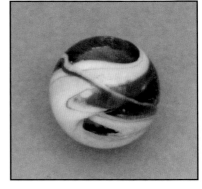

Transitional. Ground pontil, 7/8". Estimate of value: $500 to $1,000. *Courtesy of Elliot Pincus.*

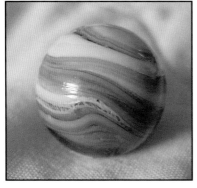

Transitional. Ground pontil, 7/8". Estimate of value: $500 to $1,000. *Courtesy of Charley Hix, Jr.*

Transitional. Ground pontil, 7/8". Estimate of value: $500 to $1,000. *Courtesy of Charley Hix, Jr.*

Transitional. Ground pontil, 7/8". Estimate of value: $500 to $1,000. *Courtesy of Charley Hix, Jr.*

Transitional. Ground pontil, 7/8".
Estimate of value: $500 to $1,000.
Courtesy of Charley Hix, Jr.

Transitional. Ground pontil, 7/8".
Opaque Royal Blue. Top view.
Estimate of value: $1,500 to
$2,000. *Courtesy of Charley Hix, Jr.*

Transitional. Ground pontil, 7/8".
Opaque Royal Blue. Side view.
Estimate of value: $1,500 to $2,000.
Courtesy of Charley Hix, Jr.

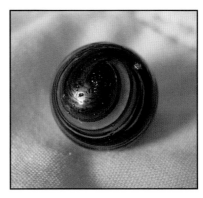

Transitional. Ground pontil, 7/8".
Estimate of value: $500 to $1,000.
Courtesy of Charley Hix, Jr.

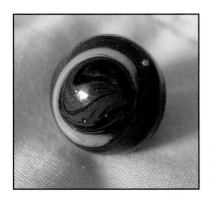

Transitional. Ground pontil, 7/8".
Estimate of value: $500 to $1,000.
Courtesy of Charley Hix, Jr.

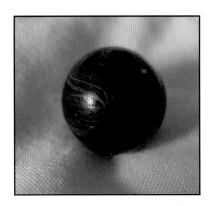

Transitional. Ground pontil, 7/8".
Estimate of value: $500 to $1,000.
Courtesy of Charley Hix, Jr.

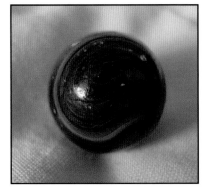

Transitional. Ground pontil, 7/8".
Estimate of value: $500 to $1,000.
Courtesy of Charley Hix, Jr.

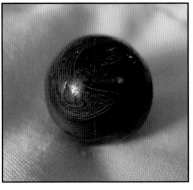

Transitional. Ground pontil, 7/8".
Estimate of value: $500 to $1,000.
Courtesy of Charley Hix, Jr.

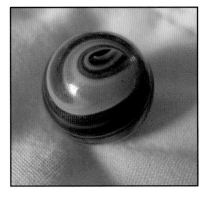

Transitional. Ground pontil, 7/8".
Estimate of value: $500 to $1,000.
Courtesy of Charley Hix, Jr.

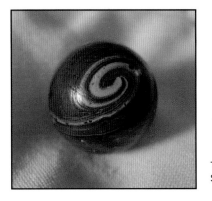

Transitional. Ground pontil, 3/4". Estimate of value:
$500 to $1,000. *Courtesy of Charley Hix, Jr.*

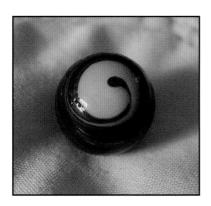

Transitional. Ground pontil, 7/8".
Estimate of value: $500 to $1,000.
Courtesy of Charley Hix, Jr.

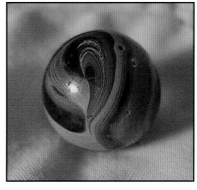

Transitional. Ground pontil, 7/8".
Estimate of value: $400 to $800.
Courtesy of Charley Hix, Jr.

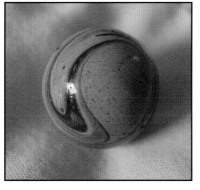

Transitional. Ground pontil, 7/8".
Estimate of value: $500 to $1,000.
Courtesy of Charley Hix, Jr.

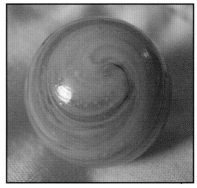

Transitional. Ground pontil, 1-1/16".
Estimate of value: $1,200 to $1,800.
Courtesy of Charley Hix, Jr.

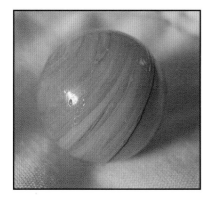

Transitional. Ground pontil, 1-1/16". Estimate of
value: $1,200 to $1,800. *Courtesy of Charley Hix, Jr.*

Transitionals 21

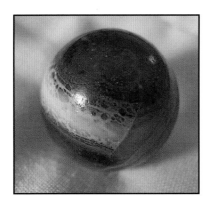

Transitional. Ground pontil, 1".
Estimate of value: $600 to $1,000.
Courtesy of Charley Hix, Jr.

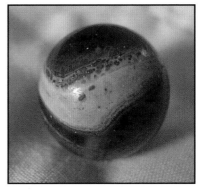

Transitional. Ground pontil, 1".
Estimate of value: $600 to $1,000.
Courtesy of Charley Hix, Jr.

Transitional. Ground pontil, 7/8".
Estimate of value: $400 to $800.
Courtesy of Charley Hix, Jr.

Transitional. Ground pontil, Tornado, 7/8".
Estimate of value: $700 to $1,000. *Courtesy
of Charley Hix, Jr.*

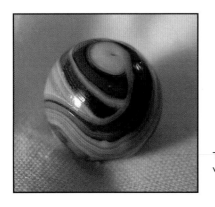

Transitional. Ground pontil, 11/16". Estimate of
value: $400 to $800. *Courtesy of Charley Hix, Jr.*

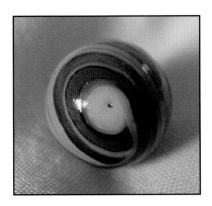

Transitional. Ground pontil, 7/8". Estimate of value: $500 to $1,000. *Courtesy of Charley Hix, Jr.*

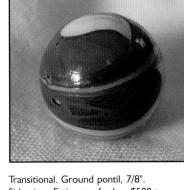

Transitional. Ground pontil, 7/8". Side view. Estimate of value: $500 to $1,000. *Courtesy of Charley Hix, Jr.*

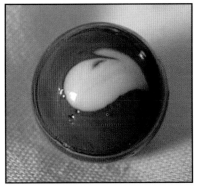

Transitional. Ground pontil, 7/8". Top view. Estimate of value: $500 to $1,000. *Courtesy of Charley Hix, Jr.*

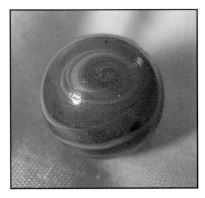

Transitional. Ground pontil, 3/4". Top view. Estimate of value: $400 to $800. *Courtesy of Charley Hix, Jr.*

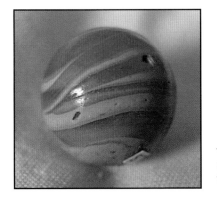

Transitional. Ground pontil, 3/4". Side view. Estimate of value: $400 to $800. *Courtesy of Charley Hix, Jr.*

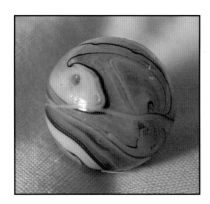

Transitional. Ground pontil, 7/8". Estimate of value: $500 to $1,000. *Courtesy of Charley Hix, Jr.*

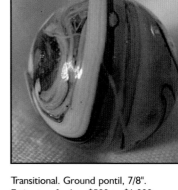

Transitional. Ground pontil, 7/8". Estimate of value: $500 to $1,000. *Courtesy of Charley Hix, Jr.*

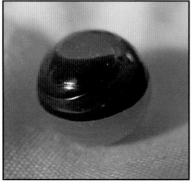

Transitional. Ground pontil, 9/16". Estimate of value: $400 to $800. *Courtesy of Charley Hix, Jr.*

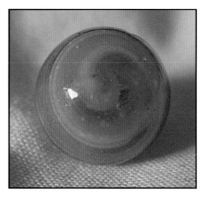

Transitional. Ground pontil, 13/16". Estimate of value: $400 to $800. *Courtesy of Charley Hix, Jr.*

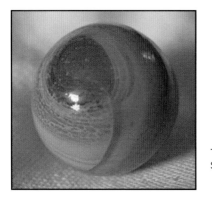

Transitional. Ground pontil, 5/8". Estimate of value: $300 to $600. *Courtesy of Charley Hix, Jr.*

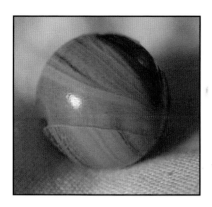

Transitional. Ground pontil, 13/16". Estimate of value: $400 to $800. *Courtesy of Charley Hix, Jr.*

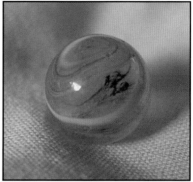

Transitional. Ground pontil, 13/16". Estimate of value: $400 to $800. *Courtesy of Charley Hix, Jr.*

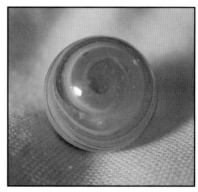

Transitional. Ground pontil, 5/8". Estimate of value: $300 to $600. *Courtesy of Charley Hix, Jr.*

Transitional. Ground pontil, 13/16". Estimate of value: $400 to $800. *Courtesy of Charley Hix, Jr.*

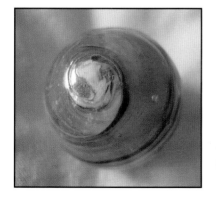

Transitional. Ground pontil, 7/8". Estimate of value: $400 to $800. *Courtesy of Charley Hix, Jr.*

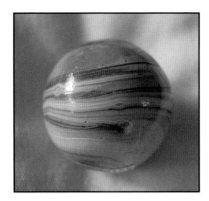

Transitional. Ground pontil, 1-1/16".
Estimate of value: $1,500 to $2,500.
Courtesy of Charley Hix, Jr.

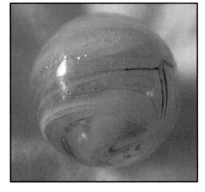

Transitional. Ground pontil, 1-1/8".
Estimate of value: $1,500 to $2,500.
Courtesy of Charley Hix, Jr.

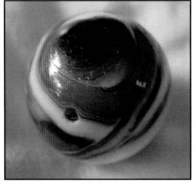

Transitional. Ground pontil, 1-3/16".
Top view. Estimate of value: $2,750
to $4,000. *Courtesy of Charley Hix, Jr.*

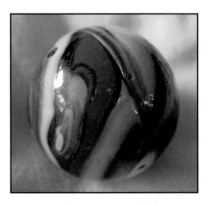

Transitional. Ground pontil, 1-3/16".
Side view. Estimate of value: $2,750
to $4,000. *Courtesy of Charley Hix, Jr.*

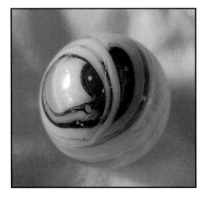

Transitional. Ground pontil, 1-3/16".
Estimate of value: $2,750 to $4,000.
Courtesy of Charley Hix, Jr.

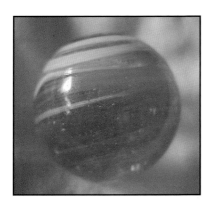

Transitional. Ground pontil, 1-3/16". Estimate of value: $1,500 to $2,500. *Courtesy of Charley Hix, Jr.*

Transitional. Ground pontil, 1-3/16". Estimate of value: $1,500 to $2,500. *Courtesy of Charley Hix, Jr.*

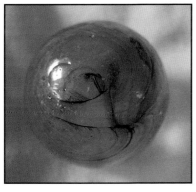

Transitional. Ground pontil, 1-3/16". Estimate of value: $2,000 to $4,000. *Courtesy of Charley Hix, Jr.*

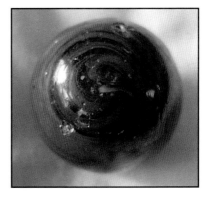

Transitional. Ground pontil, 1-3/16". Top view. Estimate of value: Too rare to value. *Courtesy of Charley Hix, Jr.*

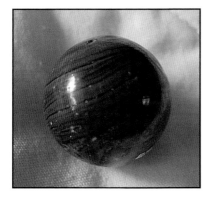

Transitional. Ground pontil, 1-3/16". Side view. Estimate of value: Too rare to value. *Courtesy of Charley Hix, Jr.*

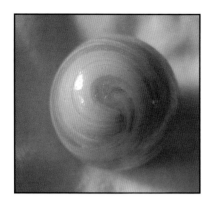

Transitional. Ground pontil, 1-3/16".
Top view. Estimate of value: $2,000 to
$3,500. *Courtesy of Charley Hix, Jr.*

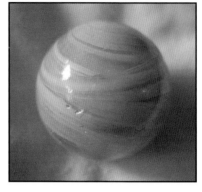

Transitional. Ground pontil, 1-3/16". Side
view. Estimate of value: $2,000 to
$3,500. *Courtesy of Charley Hix, Jr.*

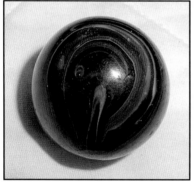

Transitional. Ground pontil, 1-1/2".
Estimate of value: $2,000 to $4,000.
Courtesy of Charley Hix, Jr.

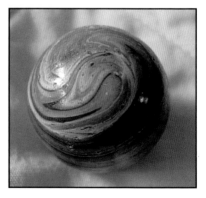

Transitional. Ground pontil, 1-1/2".
Estimate of value: $2,000 to $4,000.
Courtesy of Charley Hix, Jr.

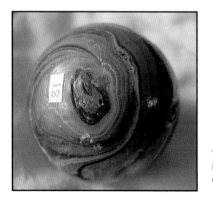

Transitional. Ground pontil, 1-1/2".
Estimate of value: $2,000 to $4,000.
Courtesy of Charley Hix, Jr.

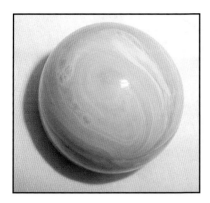

Transitional. Ground pontil, 1-1/2".
Estimate of value: $1,750 to $3,000.
Courtesy of Charley Hix, Jr.

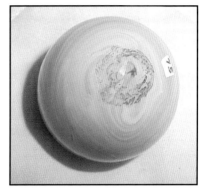

Transitional. Ground pontil, 1-1/2".
Estimate of value: $1,750 to $3,000.
Courtesy of Charley Hix, Jr.

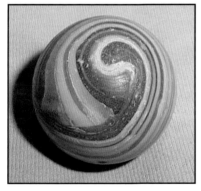

Transitional. Ground pontil, 1". Top
view. Estimate of value: $1,000 to
$2,000. *Courtesy of Lee Linne.*

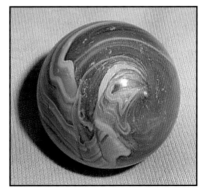

Transitional. Ground pontil, 1".
Bottom view. Estimate of value:
$1,000 to $2,000. *Courtesy of Lee
Linne.*

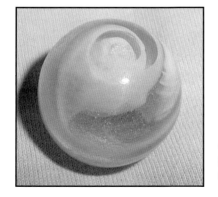

Transitional. Ground pontil, 27/32".
Estimate of value: $400 to $800.
Courtesy of Lee Linne.

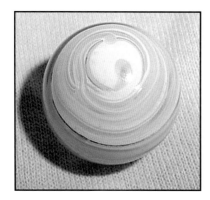

Transitional. Ground pontil, 27/32".
Top view. Estimate of value: $400 to
$800. *Courtesy of Lee Linne.*

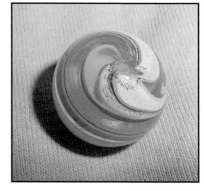

Transitional. Ground pontil, 27/32".
Bottom view. Estimate of value: $400
to $800. *Courtesy of Lee Linne.*

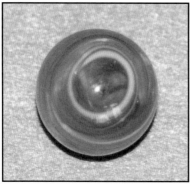

Transitional. Ground pontil, 27/32".
Estimate of value: $400 to $800.
Courtesy of Charley Hix, Jr.

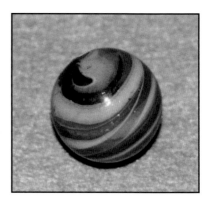

Transitional. Ground pontil, 21/32".
Estimate of value: $75 to $150.
Courtesy of Charley Hix, Jr.

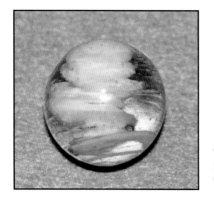

Transitional. Ground pontil, 13/16".
Estimate of value: $250 to $400.
Courtesy of Charley Hix, Jr.

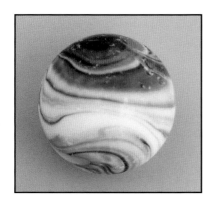

Transitional. Ground pontil, 1". Estimate of value: $400 to $800. *Courtesy of Stanley Block.*

Transitional. Ground pontil, 7/8". Estimate of value: $100 to $200. *Courtesy of Charley Hix, Jr.*

Transitional. Ground pontil, 7/8". Estimate of value: $100 to $200. *Courtesy of Charley Hix, Jr.*

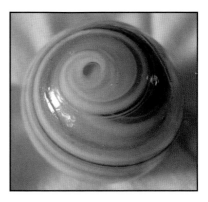

Transitional. Ground pontil, 1-3/16". Estimate of value: $600 to $1,250. *Courtesy of Charley Hix, Jr.*

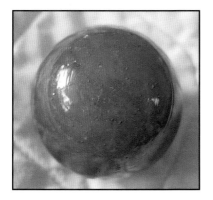

Transitional. Ground pontil, 2-1/8". Top view. Estimate of value: Too rare to value. *Courtesy of Charley Hix, Jr.*

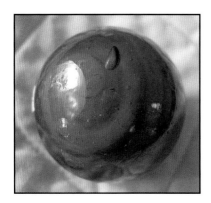

Transitional. Ground pontil, 2-1/8". Bottom view. Estimate of value: $400 to $800. *Courtesy of Charley Hix, Jr.*

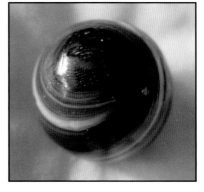

Transitional. Ground pontil, 1-3/16". Top view. Estimate of value: $600 to $1,250. *Courtesy of Charley Hix, Jr.*

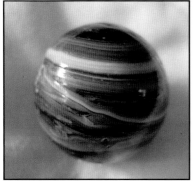

Transitional. Ground pontil, 1-3/16". Side view. Estimate of value: $600 to $1,250. *Courtesy of Charley Hix, Jr.*

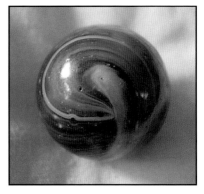

Transitional. Ground pontil, 1-3/16". Top view. Estimate of value: $600 to $1,250. *Courtesy of Charley Hix, Jr.*

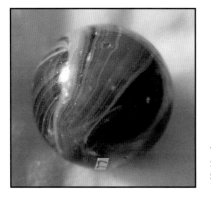

Transitional. Ground pontil, 1-3/16". Side view. Estimate of value: $600 to $1,250. *Courtesy of Charley Hix, Jr.*

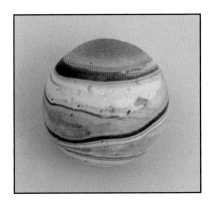

Transitional. Melted pontil, Leighton, 1-1/2". Estimate of value: $1,000 to $2,000. *Courtesy of Stanley Block.*

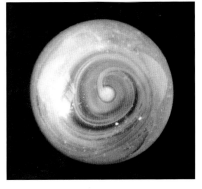

Transitional. Melted pontil, 1-1/4". Estimate of value: $1,000 to $2,000. *Courtesy of Hansel de Sousa.*

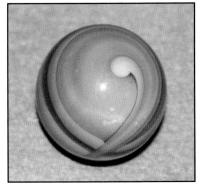

Transitional. Melted pontil, 1-1/8". Top view. Estimate of value: $1,500 to $3,000. *Courtesy of Charley Hix, Jr.*

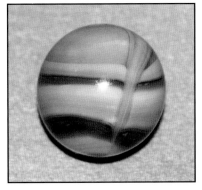

Transitional. Melted pontil, 1-1/8". Side view. Estimate of value: $1,500 to $3,000. *Courtesy of Charley Hix, Jr.*

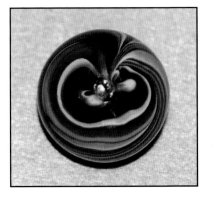

Transitional. Melted pontil, 1-1/8". Estimate of value: $1,500 to $3,000. *Courtesy of Charley Hix, Jr.*

Transitional. Melted pontil, 21/32".
Estimate of value: $40 to $80.
Courtesy of Charley Hix, Jr.

Transitional. Melted pontil, 21/32".
Estimate of value: $40 to $80.
Courtesy of Charley Hix, Jr.

Transitional. Melted pontil, 1-7/16".
Side view. Estimate of value: $1,500
to $2,500. *Courtesy of Charley Hix, Jr.*

Transitional. Melted pontil, 1-7/16".
Top view. Estimate of value: $1,500
to $2,500. *Courtesy of Charley Hix, Jr.*

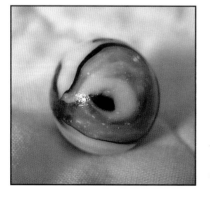

Transitional. Melted pontil, 1-1/8".
Estimate of value: $350 to $700.
Courtesy of Charley Hix, Jr.

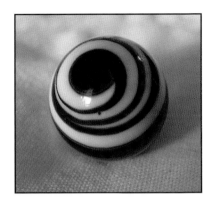

Transitional. Melted pontil, 13/16".
Estimate of value: $300 to $600. *Courtesy of Charley Hix, Jr.*

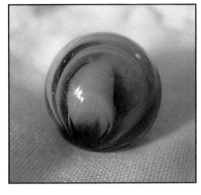

Transitional. Melted pontil, 1".
Estimate of value: $250 to $500.
Courtesy of Charley Hix, Jr.

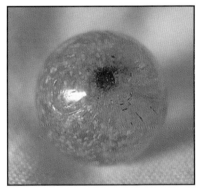

Transitional. Melted pontil, 1".
Estimate of value: $250 to $500.
Courtesy of Charley Hix, Jr.

Transitional. Melted pontil, 15/16".
Estimate of value: $200 to $400.
Courtesy of Charley Hix, Jr.

Transitional. Melted pontil, 1". Estimate
of value: $250 to $500. *Courtesy of
Charley Hix, Jr.*

Transitional. Melted pontil, 11/16".
Estimate of value: $100 to $200.
Courtesy of Charley Hix, Jr.

Transitional. Melted pontil, 5/8".
Estimate of value: $100 to $200.
Courtesy of Charley Hix, Jr.

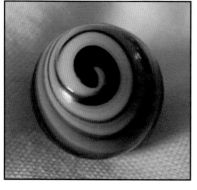

Transitional. Melted pontil, 5/8".
Estimate of value: $100 to $200.
Courtesy of Charley Hix, Jr.

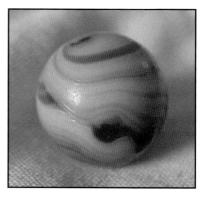

Transitional. Melted pontil, 5/8".
Estimate of value: $500 to $1,000.
Courtesy of Charley Hix, Jr.

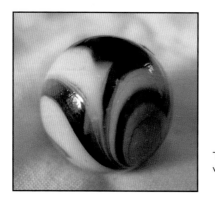

Transitional. Melted pontil, 5/8". Estimate of
value: $350 to $700. *Courtesy of Charley Hix, Jr.*

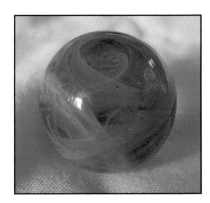

Transitional. Melted pontil, 1".
Estimate of value: $350 to $600.
Courtesy of Charley Hix, Jr.

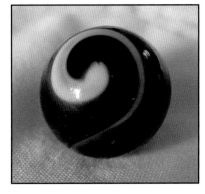

Transitional. Melted pontil, 1".
Estimate of value: $350 to $600.
Courtesy of Charley Hix, Jr.

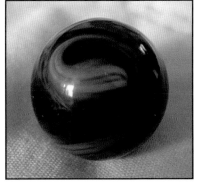

Transitional. Melted pontil, 1-1/8".
Estimate of value: $350 to $700.
Courtesy of Charley Hix, Jr.

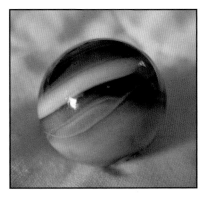

Transitional. Melted pontil, 1-1/8".
Estimate of value: $350 to $700.
Courtesy of Charley Hix, Jr.

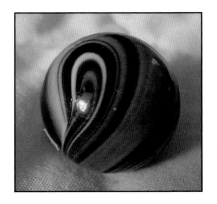

Transitional. Melted pontil, 1-1/8".
Estimate of value: $350 to $700.
Courtesy of Charley Hix, Jr.

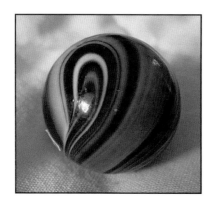

Transitional. Melted pontil, 1-1/8". Estimate of value: $500 to $1,000. *Courtesy of Charley Hix, Jr.*

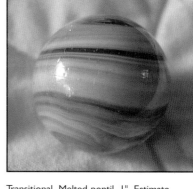

Transitional. Melted pontil, 1". Estimate of value: $350 to $600. *Courtesy of Charley Hix, Jr.*

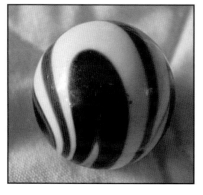

Transitional. Melted pontil, 1-3/16". Estimate of value: $600 to $1,250. *Courtesy of Charley Hix, Jr.*

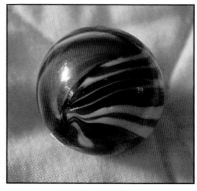

Transitional. Melted pontil, 1-3/16". Estimate of value: $600 to $1,250. *Courtesy of Charley Hix, Jr.*

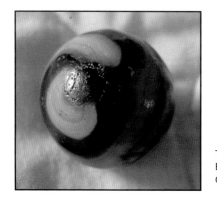

Transitional. Melted pontil, 1-7/16". Estimate of value: $1,250 to $2,500. *Courtesy of Charley Hix, Jr.*

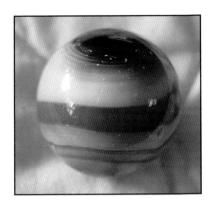

Transitional. Melted pontil, 1-1/4". Estimate of value: $700 to $1,250. *Courtesy of Charley Hix, Jr.*

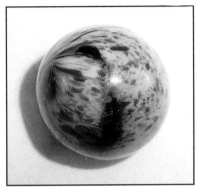

Transitional. Melted pontil, 1-1/4". Estimate of value: $1,500 to $2,500. *Courtesy of Charley Hix, Jr.*

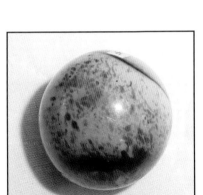

Transitional. Melted pontil, 1-1/4". Estimate of value: $1,500 to $2,500. *Courtesy of Charley Hix, Jr.*

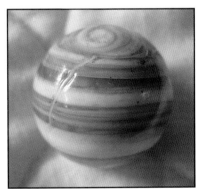

Transitional. Melted pontil, 1-1/4". Estimate of value: $700 to $1,250. *Courtesy of Charley Hix, Jr.*

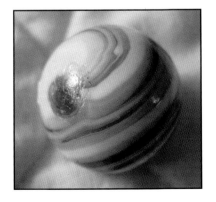

Transitional. Melted pontil, 1-1/4". Estimate of value: $700 to $1,250. *Courtesy of Charley Hix, Jr.*

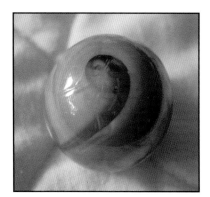

Transitional. Melted pontil, 1-1/16". Estimate of value: $400 to $800. *Courtesy of Charley Hix, Jr.*

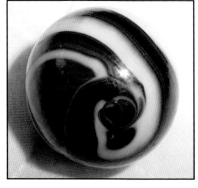

Transitional. Melted pontil, 1-1/4". Estimate of value: $700 to $1,250. *Courtesy of Charley Hix, Jr.*

Transitional. Melted pontil, 1-1/16". Estimate of value: $400 to $800. *Courtesy of Charley Hix, Jr.*

Transitional. Melted pontil, 1-1/16". Estimate of value: $400 to $800. *Courtesy of Charley Hix, Jr.*

Transitional. Melted pontil, 1-1/16". Estimate of value: $400 to $800. *Courtesy of Charley Hix, Jr.*

Transitional. Melted pontil, 1-7/16". Estimate of value: $1,250 to $2,500. *Courtesy of Charley Hix, Jr.*

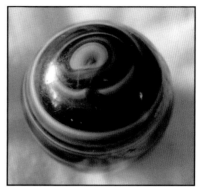

Transitional. Melted pontil, 1-7/16". Estimate of value: $1,250 to $2,500. *Courtesy of Charley Hix, Jr.*

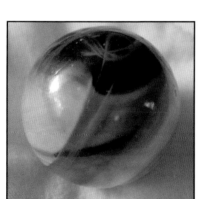

Transitional. Melted pontil, 1-7/16". Estimate of value: $1,250 to $2,500. *Courtesy of Charley Hix, Jr.*

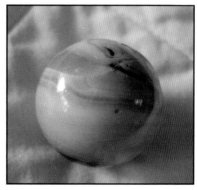

Transitional. Melted pontil, 1-7/16". Estimate of value: $1,250 to $2,500. *Courtesy of Charley Hix, Jr.*

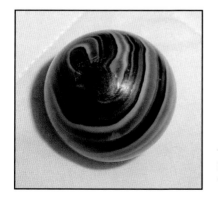

Transitional. Melted pontil, 1-7/16". Estimate of value: $1,250 to $2,500. *Courtesy of Charley Hix, Jr.*

Transitionals 41

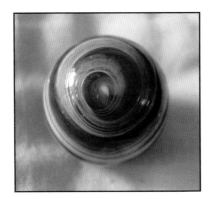

Transitional. Melted pontil, 1-3/16". Estimate of value: $600 to $1,200. *Courtesy of Charley Hix, Jr.*

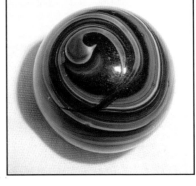

Transitional. Melted pontil, 15/16". Estimate of value: $225 to $450. *Courtesy of Charley Hix, Jr.*

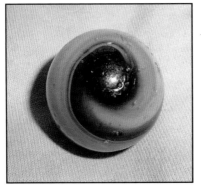

Transitional. Melted pontil, 1-3/8". Estimate of value: $450 to $900. *Courtesy of Lee Linne.*

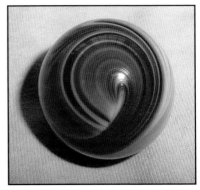

Transitional. Melted pontil, 1-3/8". Estimate of value: $450 to $900. *Courtesy of Lee Linne.*

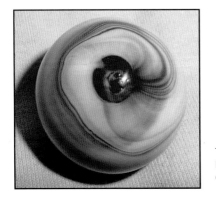

Transitional. Melted pontil, 1-1/4". Estimate of value: $375 to $750. *Courtesy of Lee Linne.*

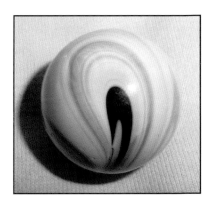

Transitional. Melted pontil, 1-1/4".
Estimate of value: $450 to $800. *Courtesy
of Lee Linne.*

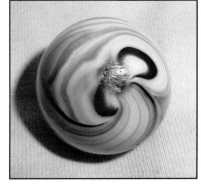

Transitional. Melted pontil, 1-1/4".
Estimate of value: $450 to $800.
Courtesy of Lee Linne.

Transitional. Melted pontil, 1-1/8".
Estimate of value: $450 to $800.
Courtesy of Lee Linne.

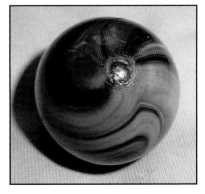

Transitional. Melted pontil, 1-1/8".
Estimate of value: $400 to $800.
Courtesy of Lee Linne.

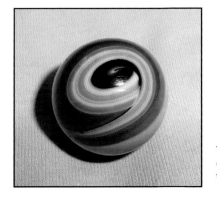

Transitional. Melted pontil, 1".
(Perfect "9") Estimate of value: $400
to $800. *Courtesy of Lee Linne.*

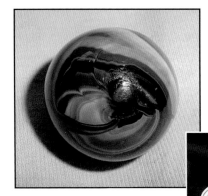

Transitional. Melted pontil, 1". Estimate of value:
$250 to $500. *Courtesy of Lee Linne.*

Transitional. Melted Pontil. Horizontal. Assorted.
Courtesy of Hansel de Sousa.

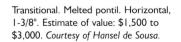

Transitional. Melted pontil. Horizontal,
1-3/8". Estimate of value: $1,500 to
$3,000. *Courtesy of Hansel de Sousa.*

Transitional. Melted pontil. Horizontal,
1-3/8". Estimate of value: $1,500 to
$3,000. *Courtesy of Hansel de Sousa.*

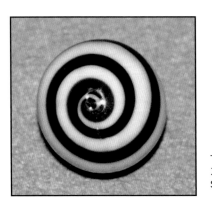

Transitional. Melted pontil. Horizontal,
31/32". Estimate of value: $1,000 to
$2,000. *Courtesy of Charley Hix, Jr.*

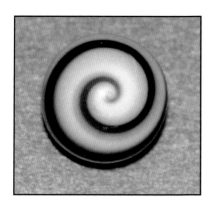

Transitional. Melted pontil. Horizontal, 25/32". Estimate of value: $750 to $1,500. *Courtesy of Charley Hix, Jr.*

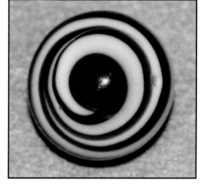

Transitional. Melted pontil. Horizontal, 25/32". Estimate of value: $750 to $1,500. *Courtesy of Charley Hix, Jr.*

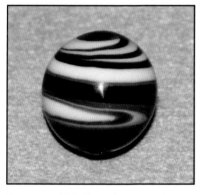

Transitional. Melted pontil. Horizontal, 25/32". Estimate of value: $750 to $1,500. *Courtesy of Charley Hix, Jr.*

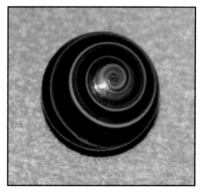

Transitional. Melted pontil. Horizontal, 21/32". Estimate of value: $200 to $400. *Courtesy of Charley Hix, Jr.*

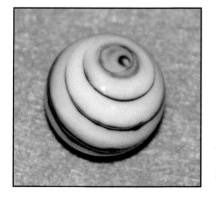

Transitional. Melted pontil. Horizontal, 11/16". Estimate of value: $200 to $400. *Courtesy of Charley Hix, Jr.*

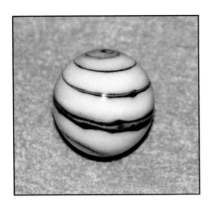

Transitional. Melted pontil. Horizontal, 11/16". Estimate of value: $200 to $400. *Courtesy of Charley Hix, Jr.*

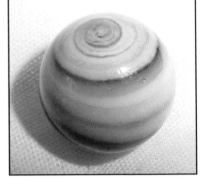

Transitional. Melted pontil. Horizontal, three color, 11/16". Estimate of value: Too rare to value. *Courtesy of Charley Hix, Jr.*

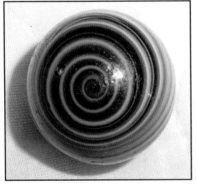

Transitional. Melted pontil. Horizontal, 1-7/16". Estimate of value: $2,000 to $4,000. *Courtesy of Charley Hix, Jr.*

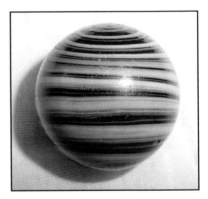

Transitional. Melted pontil. Horizontal, 1-7/16". Estimate of value: $2,000 to $4,000. *Courtesy of Charley Hix, Jr.*

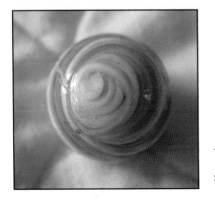

Transitional. Melted pontil. Horizontal, 1-1/4". Estimate of value: $1,500 to $3,000. *Courtesy of Charley Hix, Jr.*

Transitional. Melted pontil. Horizontal, 1-7/16". Estimate of value: $2,000 to $4,000. *Courtesy of Charley Hix, Jr.*

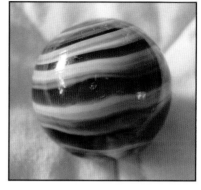

Transitional. Melted pontil. Horizontal, 1-7/16". Estimate of value: $2,000 to $4,000. *Courtesy of Charley Hix, Jr.*

Transitional. Melted pontil. Horizontal, 1-7/16". Estimate of value: $2,000 to $4,000. *Courtesy of Charley Hix, Jr.*

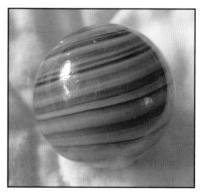

Transitional. Melted pontil. Horizontal, 1-7/16". Estimate of value: $2,000 to $4,000. *Courtesy of Charley Hix, Jr.*

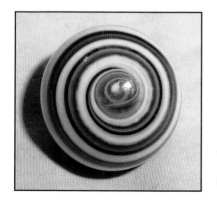

Transitional. Melted pontil. Horizontal, 1-1/8". Estimate of value: $1,250 to $2,500. *Courtesy of Lee Linne.*

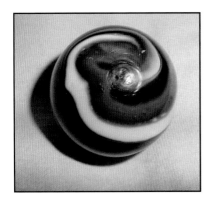

Transitional. Melted pontil. Horizontal, 1-1/8". Estimate of value: $1,250 to $2,500. *Courtesy of Lee Linne.*

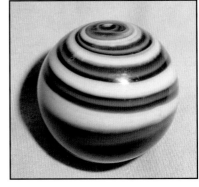

Transitional. Melted pontil. Horizontal, 1-1/8". Estimate of value: $1,250 to $2,500. *Courtesy of Lee Linne.*

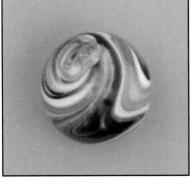

Transitional. Fold pontil, 11/16". Estimate of value: $30 to $60. *Courtesy of Stanley Block.*

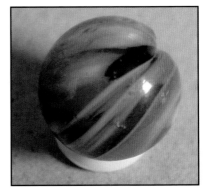

Transitional. Fold pontil, 5/8". Estimate of value: $30 to $60. *Courtesy of Stanley Block.*

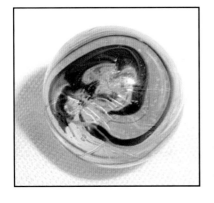

Transitional. Crease pontil, with oxblood, 11/16". Estimate of value: $150 to $300. *Courtesy of Charley Hix, Jr.*

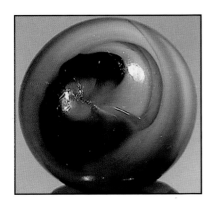

Transitional. Crease pontil, 15/16". Estimate of value: $125 to $150. *Courtesy of The AuctionBlocks.*

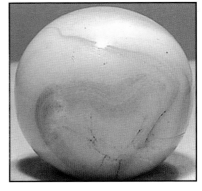

Transitional. Crease pontil, 15/16". Estimate of value: $100 to $200. *Courtesy of The AuctionBlocks.*

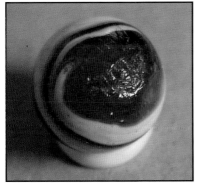

Transitional. Crease pontil, 5/8". Estimate of value: $15 to $30. *Courtesy of Stanley Block.*

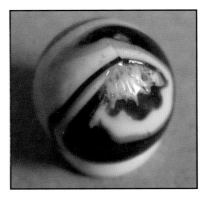

Transitional. Crease pontil, 5/8". Estimate of value: $15 to $30. *Courtesy of Stanley Block.*

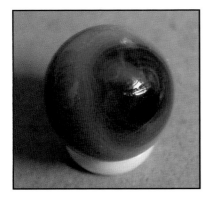

Transitional. Pinch pontil, 5/8". Estimate of value: $15 to $30. *Courtesy of Stanley Block.*

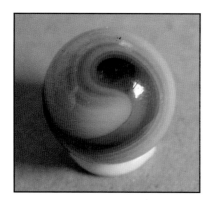

Transitional. Crease pontil (top view), 5/8". Estimate of value: $15 to $30. *Courtesy of Stanley Block.*

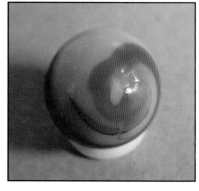

Transitional. Crease pontil, 5/8". Estimate of value: $15 to $30. *Courtesy of Stanley Block.*

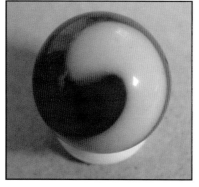

Transitional. Crease pontil (top view), 5/8". Estimate of value: $15 to $30. *Courtesy of The AuctionBlocks.*

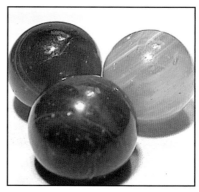

Transitional. Regular pontil, Chinese style, 9/16"-19/32". *Courtesy of The AuctionBlocks.*

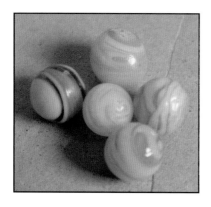

Transitional. Regular pontil, Chinese style, 9/16"-19/32". *Courtesy of Stanley Block.*

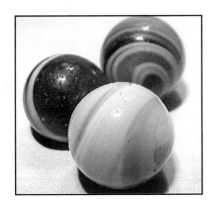

Transitional. Regular pontil, Chinese style. *Courtesy of The AuctionBlocks.*

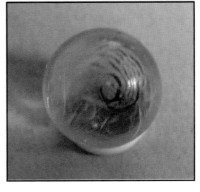

Transitional. Melted pontil showing carboning. Estimate of value: $75 to $125. *Courtesy of Stanley Block.*

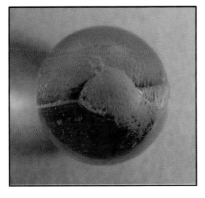

Transitional. Bullet mold, view of pontil, 11/16". Estimate of value: $25 to $50. *Courtesy of Stanley Block.*

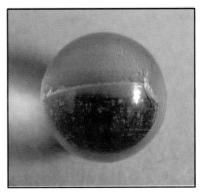

Transitional. Bullet mold, view of seam line, 11/16". Estimate of value: $25 to $50. *Courtesy of Stanley Block.*

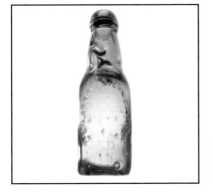

Transitional. Codd bottle (marble stopper in neck). England. Estimate of value: $20 to $40. *Courtesy of The AuctionBlocks.*

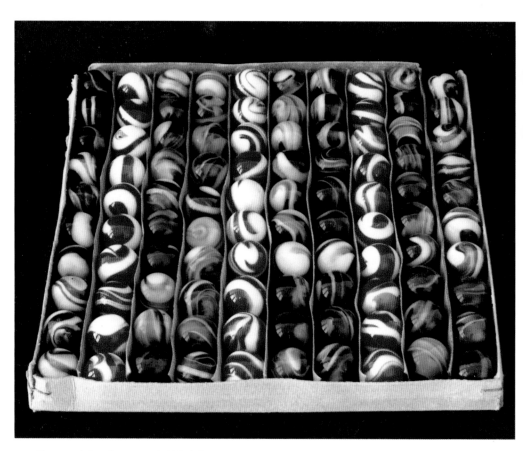

Transitional. Box (top missing), 11/16". Estimate of value: Too Rare To Value. *Courtesy of Hansel de Sousa*. The only complete box of pinch pontil transitionals known to exist. Unfortunately, the box had no top when the owner acquired it, so we cannot identify who manufactured them. However, the construction of the box bottom indicates the United States in the 1920s.

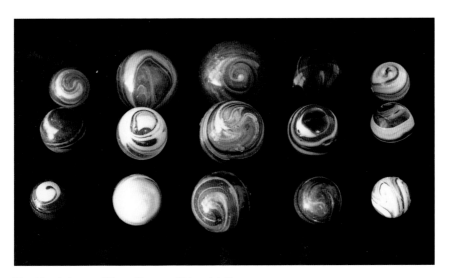

Transitional. Assorted Types. *Courtesy of Hansel de Sousa.*

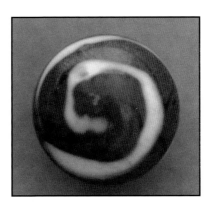

Transitional. Fake. Reworked from old glass.
Estimate of value: $50 to $100. *Courtesy of*
Block's Box Auctions.

M.F. Christensen & Son Company

Company History

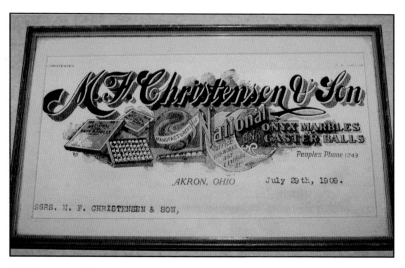

M. F. Christensen & Son Company. Company letterhead facsimile.
Estimate of value: Too Rare To Value. *Courtesy of Anonymous.*

The man who would most likely hold the title as the father of the machine made marble revolution is Martin F. Christensen. He was born in Denmark in 1849 and immigrated to the United States at the age of sixteen, eventually settling in Akron, Ohio, in the mid-1870s. A tinkerer by nature, Christensen invented a machine that could produce steel ball bearings more perfectly spherical than any machine up to that point in time.

Soon thereafter, he applied the same principal to create a machine that could produce perfectly round glass balls (marbles). He applied for a patent on this machine in 1902, and it was granted in 1905.

The design of this machine was relatively simplistic. Two bicycle wheel rims were counter-rotated next to each other. A lever allowed the rims to be moved closer together so that they almost touched each other, or moved farther apart so that a wider gap was created.

Using this machine, a marble could be made in the following manner: A gather of molten glass was picked up on a punty from a furnace pot. The wheel rims were moved together. A gob of the molten glass was dripped over the top of the wheel rims and sheared off. The glob of glass within the cavity created by the two rotating wheel rims was formed into a sphere. After a specified period of time, the rims were moved apart and the finished marble dropped into a bucket. Then the process was repeated. Sometimes, this process left a mark on one pole of the marble where it had been sheared off the gather. This mark appeared as a small seam. Further improvements eliminated the seam. The company did not use any type of automatic glass feed mechanism, all marbles were formed from hand-gathered glass. The gather was spun as it was pulled out of the furnace pot, and held on the rod. This resulted in a spiral around the

marble, usually creating a "9"-shaped swirl at the top pole of the marble. Due to the consistency of the glass as it was gathered and spun, there is usually a "tail" that spirals around the marble. Occasionally, there is a small cut-off line where the "tail" ends. This appears as faint straight line in the glass. Depending on the temperature of the glass when the marble was made, this crimp can sometimes be felt with your fingernail. Collectors have speculated that individual glassworkers can be identified by the type of "9" they made. This is because some "9"s are better formed than others. Additional research needs to be done in this area as well as the area of pontil marks on M.F. Christensen marbles.

All M.F. Christensen marbles were single-stream. This means that the colors were mixed together in a single furnace pot. M.F. Christensen marbles are almost always single-color or two-color. Some three- and four-color marbles exist, these are usually bricks or "hybrid" slags. However, even bricks are almost always two-color only. It is somewhat surprising that M.F. Christensen did not make more multi-colored marbles. It would have been a relatively simple matter to mix more than two colors in the pot. However, the company based their marketing on the fact that their marbles were rounder than handmade marbles (and had no pontil mark to throw off the shooting path) and that they were cheaper than handmade marbles. Until late in the company's life there were no competitors making marbles by machine, so there was no reason for the company to compete utilizing colors and patterns. M.F. Christensen competed in the marble market based on functional superiority and price.

While the concept of making glass marbles in a machine with rotating channels seems commonplace and self-evident to us today, this was a revolutionary concept in the early 1900s. Previously, all glass marbles had been made completely by hand. Some clay marbles were made utilizing rotating forms that had channels, however this concept was not applied to glass marbles until Martin Christensen created his machine. Later in the company's history, the machinery was modified to control numerous pairs of rotating wheel rims with one lever, thus creating a mass production technique.

Utilitizing his new machine, Martin Christensen founded The M.F. Christensen & Son Company in 1903 with his son, Charles Christensen. They built a factory in the 400 block of Exchange Street in Akron, and hired a glass master, Harry Heinzelman, a former employee of the Navarre Glass Marble and Specialty Company. Glass formulae were purchased from James H. Leighton.

Martin Christensen's invention allowed his company to become the first truly successful American marble company. The company's peak production was reached in 1914. Martin Christensen died in 1915 and Charles, who assumed control of the company upon his father's death, passed away in 1922. In 1915, Horace Hill, the company's bookkeeper, embezzled money from the company. He also stole glass recipes and machinery plans from the company and left to work for the Akro Agate Company. By 1921, Akro's more efficient production techniques had driven the M.F. Christensen & Son Company out of business.

Types of Marbles

Single Pontil Slags

The earliest M.F. Christensen marbles are single pontil slags, generically called "transitionals." It is likely that, besides Harry Heinzelman and James Harvey Leighton, Martin Christensen hired glass workers who had made marbles at other companies. As a result, many "transitional" marbles that collectors identify as M.F. Christensen & Son Company may in fact have been made at one of the earlier companies discussed in the Transitional section of this book.

Opaques

M.F. Christensen & Son Company produced hand-gathered opaque marbles, identified by a faint "9" visible in the glass. Colors included green (Oriental Jade), light green (Imperial Jade), light blue (Persion Turquoise), dark blue (Royal Blue), yellow, and lavender. The lavender is said to have been a single run of 45,000 marbles.

Slags

Slags are two-color marbles using glass from a single furnace pot. Usually the glass mixture consisted of a transparent color with opaque white swirled in. The disparate densities of the two colors mean that they did not blend. The glass retained its distinct coloring and structure within the transparent color. As with "transitionals," the company was attempting to mimic stone (predominately agate) marbles.

Slags were called National Onyx by the company and were available in a wide variety of col-

ors including various shades of amber, purple, blue, green, clear, aqua, yellow, and orange. There is a much wider variation of hue in M.F. Christensen & Son Company slags than is seen in the slags of later companies. Whether this is by design or due to the inability of the company to accurately replicate colors is not known. Some slags were produced in very large (1-1/2") sizes.

There is a type of slag marble produced by M.F. Christensen & Son Company that was called a "Moss Agate," not a "National Onyx." These are oxblood slags that have a very dark transparent green base and an oxblood swirl.

Bricks

Perhaps the most collectible M.F. Christensen & Son Company marbles are "Bricks," called "American Cornelian" by the company. Essentially, these are slag marbles where one of the colors is a deep oxblood red. The oxblood can be swirled with opaque white, opaque black, and/or translucent to transparent green swirls. Some with blue are also known to exist, but these are extremely rare.

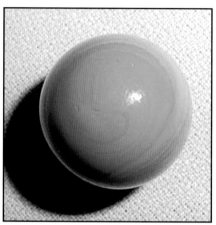

M. F. Christensen & Son Company. Opaque, 3/4". Estimate of value: $250 to $500. *Courtesy of Terry Lundeen.*

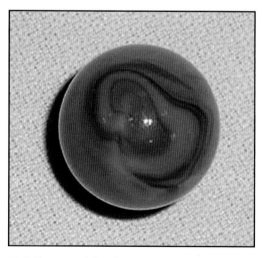

M. F. Christensen & Son Company. Opaque, 3/4". Estimate of value: $250 to $500. *Courtesy of Terry Lundeen.*

M. F. Christensen & Son Company. Opaque. *Courtesy of Art Boltz.*

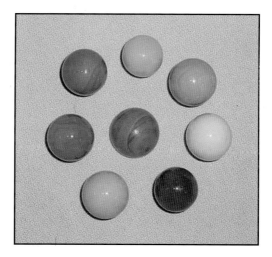

M. F. Christensen & Son Company. Opaque, 23/32" to 3/4". *Courtesy of Terry Lundeen.*

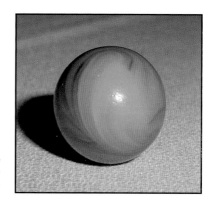

M. F. Christensen & Son Company. Opaque, 3/4". Estimate of value: $250 to $500. *Courtesy of Terry Lundeen.*

M. F. Christensen & Son Company 57

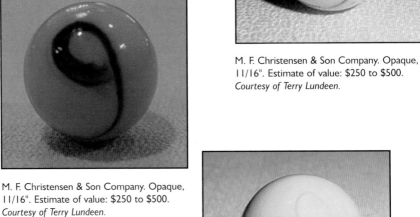

M. F. Christensen & Son Company. Opaque,
11/16". Estimate of value: $250 to $500.
Courtesy of Terry Lundeen.

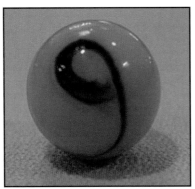

M. F. Christensen & Son Company. Opaque,
11/16". Estimate of value: $250 to $500.
Courtesy of Terry Lundeen.

M. F. Christensen & Son Company. Opaque,
3/4". Estimate of value: $250 to $500.
Courtesy of Terry Lundeen.

M. F. Christensen & Son Company. Opaque
(portion), 7/8". *Courtesy of Terry Lundeen.*

M. F. Christensen & Son Company. Assorted
cullet and marble rejects. Estimate of value:
$60 to $100. *Courtesy of Robert Block.*

M. F. Christensen & Son Company. Slag.
Green, 3/4". Estimate of value: $35 to $50.
Courtesy of Stanley Block.

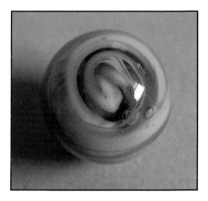

M. F. Christensen & Son Company. Slag.
Green, 1". Estimate of value: $100 to $175.
Courtesy of Stanley Block.

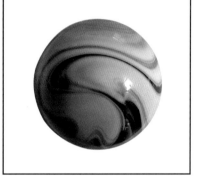

M. F. Christensen & Son Company. Slag.
Green, 1-1/4". Estimate of value: $300 to
$500. *Courtesy of Robert Block.*

M. F. Christensen & Son Company. Slag.
Green with lavender, 3/4". Estimate of
value: $125 to $250. *Courtesy of Terry
Lundeen.*

M. F. Christensen & Son Company. Slag. Green
with lavender, 3/4". Estimate of value: $125 to
$250. *Courtesy of Terry Lundeen.*

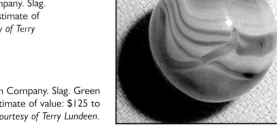

M. F. Christensen & Son Company 59

M. F. Christensen & Son Company. Slag. Green with oxblood, 3/4". Estimate of value: $300 to $600. *Courtesy of Terry Lundeen.*

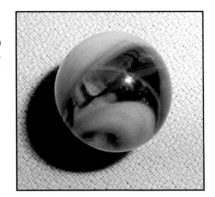

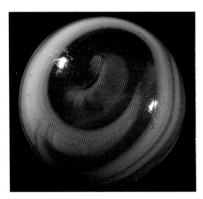

M. F. Christensen & Son Company. Slag. Green with oxblood, 3/4". Estimate of value: $300 to $600. *Courtesy of Terry Lundeen.*

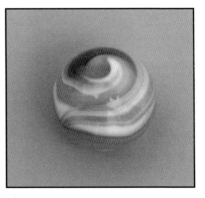

M. F. Christensen & Son Company. Slag. Brown, 3/4". Estimate of value: $20 to $40. *Courtesy of Stanley Block.*

M. F. Christensen & Son Company. Slag. Brown, 1". Estimate of value: $40 to $80. *Courtesy of Les Jones. (Photo courtesy of Bill Tow.)*

M. F. Christensen & Son Company. Slag. Brown, 11/16" and 3/4". *Courtesy of Bill Tow. (Photo courtesy of Bill Tow.)*

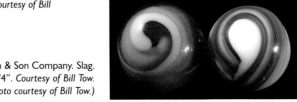

M. F. Christensen & Son Company. Slag. Brown, 15/16". Estimate of value: $125 to $200. *Courtesy of Stanley Block.*

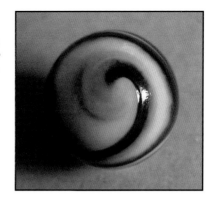

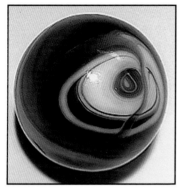

M. F. Christensen & Son Company. Slag. Brown, 1". Estimate of value: $75 to $125. *Courtesy of The AuctionBlocks.*

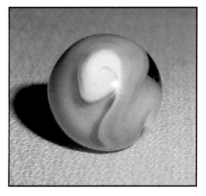

M. F. Christensen & Son Company. Slag. Lavender, 3/4". Estimate of value: $25 to $50. *Courtesy of Terry Lundeen.*

M. F. Christensen & Son Company. Slag. Brown, 1". Estimate of value: $75 to $125. *Courtesy of Stanley Block.*

M. F. Christensen & Son Company. Slag. Blue, 3/4". Estimate of value: $45 to $60. *Courtesy of Stanley Block.*

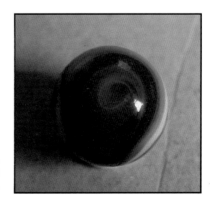

M. F. Christensen & Son Company. Oxblood
Slag, 3/4". Estimate of value: $300 to $600.
Courtesy of Terry Lundeen.

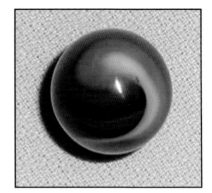

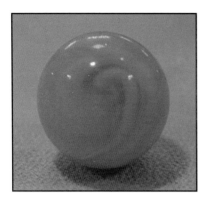

M. F. Christensen & Son Company. Slag.
Yellow, 3/4". Estimate of value: $35 to $70.
Courtesy of Terry Lundeen.

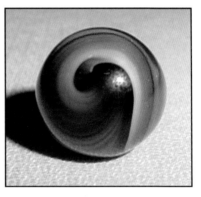

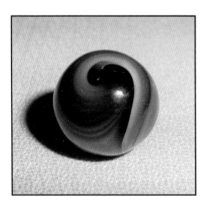

M. F. Christensen & Son Company. Oxblood
Slag, 3/4". Estimate of value: $300 to $600.
Courtesy of Terry Lundeen.

M. F. Christensen & Son Company. Oxblood
Slag, 3/4". Estimate of value: $300 to $600.
Courtesy of Terry Lundeen.

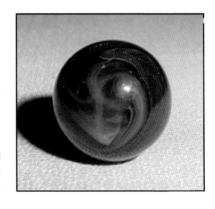

M. F. Christensen & Son Company. Oxblood
Slag, 3/4". Estimate of value: $300 to $600.
Courtesy of Terry Lundeen.

M. F. Christensen & Son Company. Oxblood Slag, 3/4". Estimate of value: $300 to $600. *Courtesy of Terry Lundeen.*

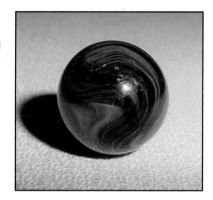

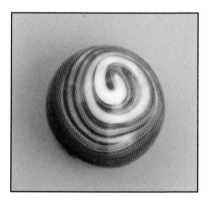

M. F. Christensen & Son Company. Oxblood Slag, 7/8". Estimate of value: $450 to $900. *Courtesy of Terry Lundeen.*

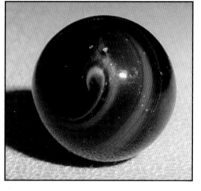

M. F. Christensen & Son Company. Oxblood Slag, 7/8". Estimate of value: $450 to $900. *Courtesy of Terry Lundeen.*

M. F. Christensen & Son Company. Brick, 15/16". Estimate of value: $325 to $650. *Courtesy of Stanley Block.*

M. F. Christensen & Son Company. Brick, 7/8". Estimate of value: $275 to $550. *Courtesy of Stanley Block.*

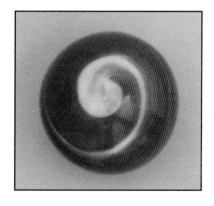

M. F. Christensen & Son Company. Brick, 3/4".
Estimate of value: $125 to $250. *Courtesy of
Stanley Block.*

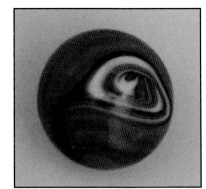

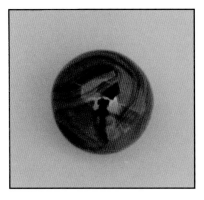

M. F. Christensen & Son Company.
Brick, 3/4". Estimate of value: $125 to
$250. *Courtesy of Stanley Block.* .

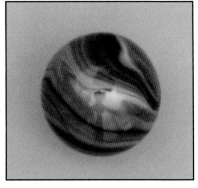

M. F. Christensen & Son Company.
Brick, 3/4". Estimate of value: $125 to
$250. *Courtesy of Stanley Block.*

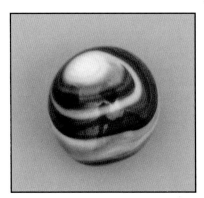

M. F. Christensen & Son Company.
Brick, 3/4". Estimate of value: $125 to
$250. *Courtesy of Stanley Block.*

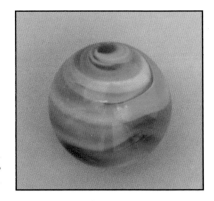

M. F. Christensen & Son Company.
Brick, 1". Estimate of value: $400 to
$800. *Courtesy of Stanley Block.*

M. F. Christensen & Son Company. Brick,
7/8". Estimate of value: $275 to $550.
Courtesy of Les Jones.

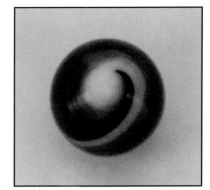

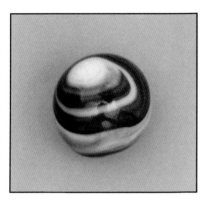

M. F. Christensen & Son Company. Brick,
3/4". Estimate of value: $125 to $250.
Courtesy of Stanley Block.

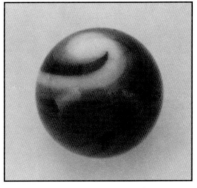

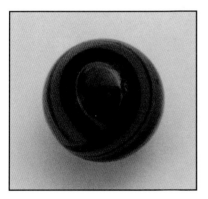

M. F. Christensen & Son Company.
Brick, 7/8". Estimate of value: $275 to
$550. *Courtesy of Les Jones.*

M. F. Christensen & Son Company. Brick,
15/16". Estimate of value: $325 to $650.
Courtesy of Anonymous.

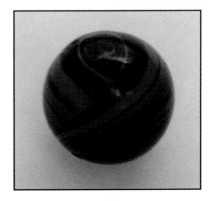

M. F. Christensen & Son Company. Brick,
15/16". Estimate of value: $325 to $650.
Courtesy of Anonymous.

M. F. Christensen & Son Company. Brick, 3/4". Estimate of value: $125 to $250. *Courtesy of Terry Lundeen.*

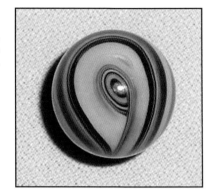

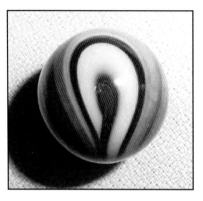

M. F. Christensen & Son Company. Brick, 27/32". Estimate of value: $275 to $550. *Courtesy of Terry Lundeen.*

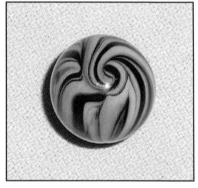

M. F. Christensen & Son Company. Brick, 3/4". Estimate of value: $125 to $250. *Courtesy of Terry Lundeen.*

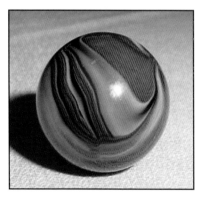

M. F. Christensen & Son Company. Brick, 7/8". Estimate of value: $275 to $550. *Courtesy of Terry Lundeen.*

M. F. Christensen & Son Company. Brick, 7/8". Estimate of value: $275 to $550. *Courtesy of Terry Lundeen.*

M. F. Christensen & Son Company.
Brick, 3/4". Estimate of value: $125 to
$250. *Courtesy of Terry Lundeen.*

M. F. Christensen & Son Company. Brick,
7/8". Estimate of value: $275 to $550.
Courtesy of Terry Lundeen.

M. F. Christensen & Son Company. Brick,
3/4". Estimate of value: $125 to $250.
Courtesy of Terry Lundeen.

M. F. Christensen & Son Company.
Brick, 7/8". Estimate of value: $275 to
$550. *Courtesy of Terry Lundeen.*

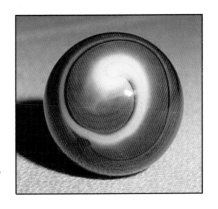

M. F. Christensen & Son Company.
Brick, 7/8". Estimate of value: $275 to
$550. *Courtesy of Terry Lundeen.*

M. F. Christensen & Son Company. Brick, 3/4". An example of an American Cornelian after it has been played with, showing the origin of the name "Brick." Estimate of value: $125 to $250. *Courtesy of Terry Lundeen.*

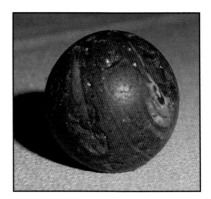

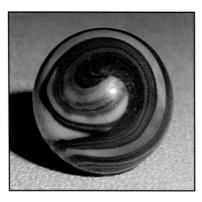

M. F. Christensen & Son Company. Brick, 7/8". Estimate of value: $275 to $550. *Courtesy of Terry Lundeen.*

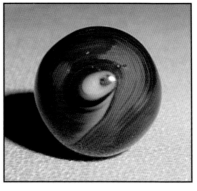

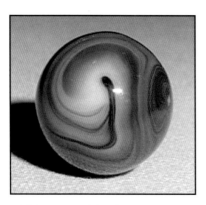

M. F. Christensen & Son Company. Brick, 3/4". Estimate of value: $125 to $250. *Courtesy of Terry Lundeen.*

M. F. Christensen & Son Company. Brick, 3/4". Estimate of value: $125 to $250. *Courtesy of Terry Lundeen.*

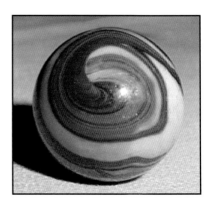

M. F. Christensen & Son Company. Brick, 3/4". Estimate of value: $125 to $250. *Courtesy of Terry Lundeen.*

M. F. Christensen & Son Company. Brick,
3/4". Estimate of value: $125 to $250.
Courtesy of Terry Lundeen.

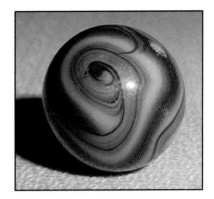

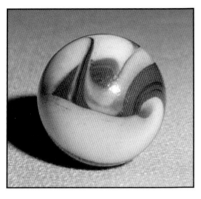

M. F. Christensen & Son Company.
Brick, 3/4". Estimate of value: $125 to
$250. *Courtesy of Terry Lundeen.*

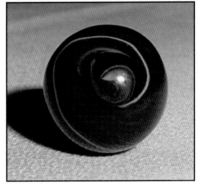

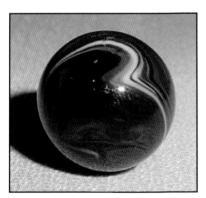

M. F. Christensen & Son Company. Brick,
3/4". Estimate of value: $125 to $250.
Courtesy of Terry Lundeen.

M. F. Christensen & Son Company.
Brick, 3/4". Estimate of value: $125 to
$250. *Courtesy of Terry Lundeen.*

M. F. Christensen & Son Company.
Brick, 3/4". Estimate of value: $125 to
$250. *Courtesy of Terry Lundeen.*

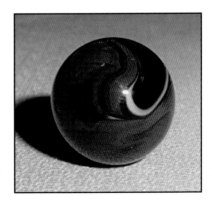

M. F. Christensen & Son Company.
Box. No. 1 Persian Turquoise (Box
top). Estimate of value: Too Rare To
Value. *Courtesy of Hansel de Sousa.*

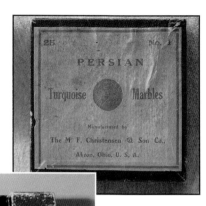

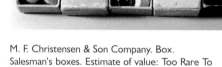

M. F. Christensen & Son Company. Box.
Salesman's boxes. Estimate of value: Too Rare To
Value. *Courtesy of Stanley Block.*

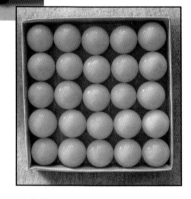

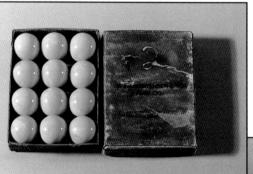

M. F. Christensen & Son Company.
Box. No. 1 Persian Turquoise (Box
interior). Estimate of value: Too Rare
To Value. *Courtesy of Hansel de Sousa.*

M. F. Christensen & Son Company. Box. No. 2
Persion Turquoise. Estimate of value: Too Rare
To Value. *Courtesy of Peter Sharrer.*

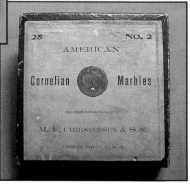

M. F. Christensen & Son Company. Box. #2
American Cornelians (Box top). Estimate of value:
Too Rare To Value. *Courtesy of Peter Sharrer.*

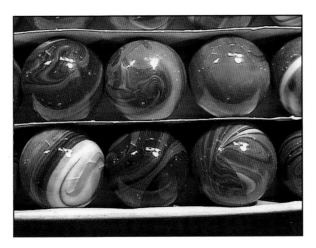

M. F. Christensen & Son Company. Box. #2
American Cornelians (Box interior). Estimate of
value: Too Rare To Value. *Courtesy of Peter Sharrer.*

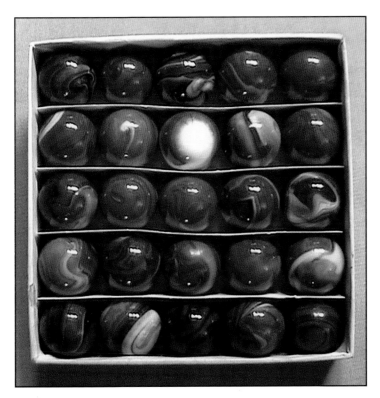

M. F. Christensen & Son Company. Box. #2 American
Cornelians (Box interior). Estimate of value: Too Rare To Value.
Courtesy of Peter Sharrer.

M. F. Christensen & Son Company. Box. Gift set. Estimate of value: Too Rare To Value. *Courtesy of Nancy Zeloski.*

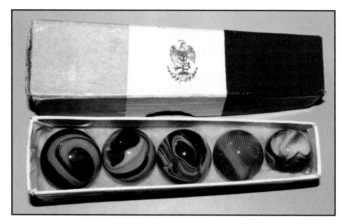

M. F. Christensen & Son Company. Box. Gift set. Estimate of value: Too Rare To Value. *Courtesy of Nancy Zeloski.*

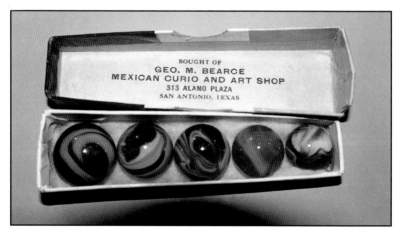

M. F. Christensen & Son Company. Box. Gift set. Estimate of value: Too Rare To Value. *Courtesy of Nancy Zeloski.*

The First and Original Glass Marble Factory in America

M. F. Christensen & Son Company. Original Brochure.
Estimate of value: Too Rare To Value. *Courtesy of Peter Sharrer.*

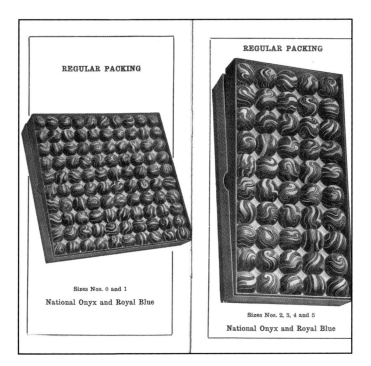

M. F. Christensen & Son Company. Original Brochure. Estimate of value: Too
Rare To Value. *Courtesy of Peter Sharrer.*

M. F. Christensen & Son Company 73

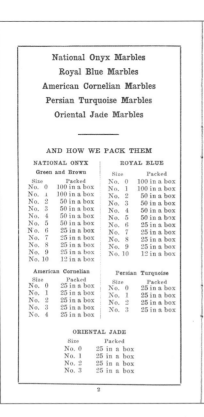

National Onyx Marbles
Royal Blue Marbles
American Cornelian Marbles
Persian Turquoise Marbles
Oriental Jade Marbles

AND HOW WE PACK THEM

NATIONAL ONYX		ROYAL BLUE	
Green and Brown			
Size	Packed	Size	Packed
No. 0	100 in a box	No. 0	100 in a box
No. 1	100 in a box	No. 1	100 in a box
No. 2	50 in a box	No. 2	50 in a box
No. 3	50 in a box	No. 3	50 in a box
No. 4	50 in a box	No. 4	50 in a box
No. 5	50 in a box	No. 5	50 in a box
No. 6	25 in a box	No. 6	25 in a box
No. 7	25 in a box	No. 7	25 in a box
No. 8	25 in a box	No. 8	25 in a box
No. 9	25 in a box	No. 9	25 in a box
No. 10	12 in a box	No. 10	12 in a box

American Cornelian		Persian Turquoise	
Size	Packed	Size	Packed
No. 0	25 in a box	No. 0	25 in a box
No. 1	25 in a box	No. 1	25 in a box
No. 2	25 in a box	No. 2	25 in a box
No. 3	25 in a box	No. 3	25 in a box
No. 4	25 in a box		

ORIENTAL JADE

Size	Packed
No. 0	25 in a box
No. 1	25 in a box
No. 2	25 in a box
No. 3	25 in a box

2

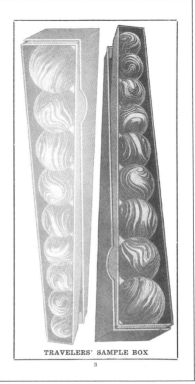

TRAVELERS' SAMPLE BOX

3

M. F. Christensen & Son Company. Original Brochure.
Estimate of value: Too Rare To Value. *Courtesy of Peter Sharrer.*

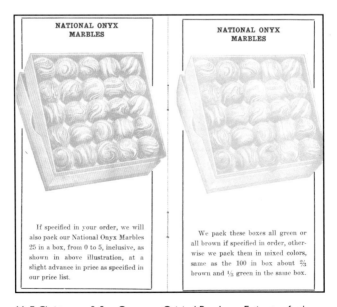

NATIONAL ONYX
MARBLES

NATIONAL ONYX
MARBLES

If specified in your order, we will also pack our National Onyx Marbles 25 in a box, from 0 to 5, inclusive, as shown in above illustration, at a slight advance in price as specified in our price list.

We pack these boxes all green or all brown if specified in order, otherwise we pack them in mixed colors, same as the 100 in box about ⅔ brown and ⅓ green in the same box.

M. F. Christensen & Son Company. Original Brochure. Estimate of value: Too Rare To Value. *Courtesy of Peter Sharrer.*

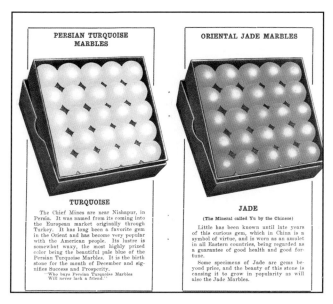

PERSIAN TURQUOISE MARBLES

ORIENTAL JADE MARBLES

TURQUOISE

The Chief Mines are near Nishapur, in Persia. It was named from its coming into the European market originally through Turkey. It has long been a favorite gem in the Orient and has become very popular with the American people. Its lustre is somewhat waxy, the most highly prized color being the beautiful pale blue of the Persian Turquoise Marbles. It is the birth stone for the month of December and signifies Success and Prosperity.

"Who buys Persian Turquoise Marbles Will never lack a friend."

JADE

(The Mineral called Yu by the Chinese)

Little has been known until late years of this curious gem, which in China is a symbol of virtue, and is worn as an amulet in all Eastern countries, being regarded as a guarantee of good health and good fortune.

Some specimens of Jade are gems beyond price, and the beauty of this stone is causing it to grow in popularity as will also the Jade Marbles.

M. F. Christensen & Son Company. Original Brochure. Estimate of value: Too Rare To Value. *Courtesy of Peter Sharrer.*

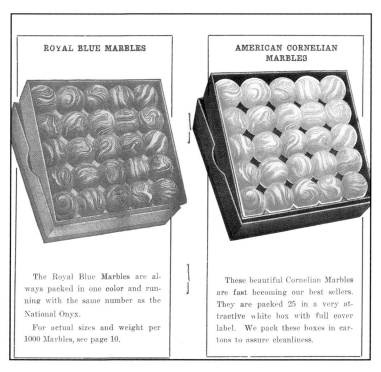

ROYAL BLUE MARBLES

AMERICAN CORNELIAN MARBLES

The Royal Blue Marbles are always packed in one color and running with the same number as the National Onyx.

For actual sizes and weight per 1000 Marbles, see page 10.

These beautiful Cornelian Marbles are fast becoming our best sellers. They are packed 25 in a very attractive white box with full cover label. We pack these boxes in cartons to assure cleanliness.

M. F. Christensen & Son Company. Original Brochure. Estimate of value: Too Rare To Value. *Courtesy of Peter Sharrer.*

M. F. Christensen & Son Company 75

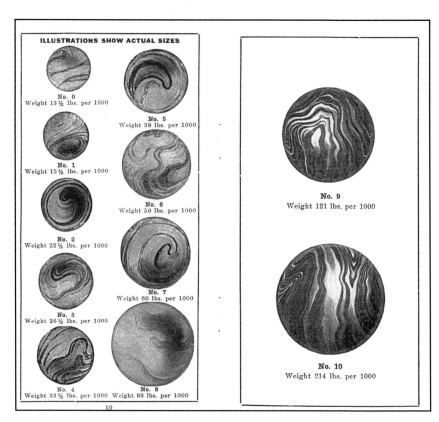

M. F. Christensen & Son Company. Original Brochure. Estimate of
value: Too Rare To Value. *Courtesy of Peter Sharrer.*

M. F. Christensen & Son Company. Original Brochure. Estimate
of value: Too Rare To Value. *Courtesy of Peter Sharrer.*

M. F. Christensen & Son Company. Original Brochure. Estimate of value: Too
Rare To Value. *Courtesy of Peter Sharrer.*

M. F. Christensen & Son Company. Original Brochure. Estimate of
value: Too Rare To Value. *Courtesy of Peter Sharrer.*

Christensen Agate Company

Company History

The Christensen Agate Company was founded by a group of businessmen: W.F. Jones, H.H. Culper, Owen M. Roderick, Robert C. Ryder, and Beaulah P. Hartman. However, the heart and soul of the company were two other men. One was the glass chemist Arnold Fiedler (later to head the company), originally from Germany, who was previously employed at the Cambridge Glass Company. The other was Howard M. Jenkins. He became president of Christensen Agate and also created and patented its marble-making machinery. The patent was granted in 1924.

Officially, the Christensen Agate Company was founded in 1925, and ceased to exist in 1933. However, the peak production period of the beautiful marbles for which it is so well known was much shorter, 1927 through late 1929 or early 1930. Why the company was named Christensen Agate is lost to the mists of time. It is likely that the founders were attempting to capitalize on the well-known glass name of Martin Christensen. The M.F. Christensen & Son Company and the Christensen Agate Company are not related in any filial or financial manner, other than they both produced marbles. However, the two companies are closely linked as the two earliest innovators of the American marble industry. The M.F. Christensen & Son Company changed the industry forever with its revolutionary machinery and processes. The Christensen Agate Company changed the industry with its innovative colors and designs. While neither company was a commercial success, they both created innovations which contemporaneous and later companies utilized to expand and succeed.

Upon its founding, the company was located in Payne, Ohio. In 1927, it moved over 200 miles to the southeast to a small brick building on Bennett Avenue in Cambridge, Ohio, near the Cambridge Glass Company. This was a strategic move, as Christensen Agate purchased scrap glass from Cambridge Glass Company. The town of Cambridge was also offering incentives to draw industries to the area, so the move made financial sense as well.

It is currently unknown what type of marbles were produced at the Payne, Ohio, location. Probably the early hand-gathered swirls were produced there, as well as some slags. It also may be that the company began operations by producing clays or repackaging clays they bought from other manufacturers. When the Cambridge facility was cleared out, there were quantities of hand-gathered slags there, as well as clays packaged in Christensen Agate boxes with Albright Company labels on them. It has been suggested that this was stock left over from the Payne, Ohio, location.

It was at the Cambridge location that the Christensen Agate Company blossomed, following the hiring of Arnold Fiedler. Fielder used skills and technical knowledge he had acquired in Germany and at Cambridge Glass to produce an amazing palette of colors never before seen in marbles. His glass formulae were closely guarded trade secrets and neither Peltier Glass Company, nor Akro Agate Company, could produce anything resembling them. Unfortunately, the materials used to produce the colors were very expensive and this led to the company's demise at the advent of the Great Depression. Fielder eventually went to work for Akro Agate Company. It is likely that other former employees of Christensen Agate went to work for Lawrence Alley at some of his companies.

Christensen Agate Company possessed the first automatic feed system for manufacturing marbles. This system, referred to as "gob feeder," was developed under contract with the Hartford Empire Company. Hartford Empire held the patents for the gob feeder concept, and they adapted it to marble manufacture. The technology was added to Christensen Agate Company's production line when the company moved to their Cambridge facility.

Christensen Agate Company marbles are hard to find, relative to the marbles of other companies. Production was very small (some

have suggested less than 300,000 marbles per day, even at the peak of production) and the company did not operate for very long. In addition, Christensen Agate did not have a wide distribution system, unlike the other companies of the time: M.F. Christensen, Akro Agate, and Peltier Glass. Company records and anecdotal evidence suggest that most of the marbles were sold only in the Ohio area, with some limited distribution to the Eastern seaboard via The Gropper Onyx Company.

Types of Marbles

Hand-gathered Swirls

Hand-gathered swirls are one of the rarest types of Christensen Agate marbles. These are two opaque colors that were swirled in a furnace pot. The glass was probably then gathered and dripped into a machine (likely Jenkins' machine). The marbles exhibit the distinctive "9" type pattern at the top pontil and usually a crimp or seam mark at the bottom. Initially collectors felt these were M.F. Christensen & Son Company marbles, however company research has not turned up any mention of them. On the other hand, some of these colors have been found in the later pastel opaques (which have been found in original Christensen Agate boxes). Also, the gathering pattern is similar to that found on some of the American Agates.

Opaques

Christensen Agate produced, in fairly limited quantity, a variety of opaque marbles. These are single and double seam marbles and are usually found in pastel type colors. They are very rare.

The company also produced a semi-opaque marble which they marketed as "World's Best Moon." These are semi-opaque white marbles that are opalescent (glow orange when a light is shone through them), but also have a faint bluish tint to them. The name is a play on the mineral Moonstone, which has the same glow. The company may have named them "World's Best" as a poke at Akro Agate Company, which had a similar marble that they marketed simply as "Moonie."

Slags

Christensen Agate produced two types of slags. The earlier type is hand-gathered. Usually found in shades of olive green and olive brown, there are some in electric colors. It is believed that most of these were made at the Payne, Ohio, location.

More common are the single and double seam slags. These were produced in a variety of colors, many much more exciting than their competitors'. These colors include blue, aqua, green, brown, clear, purple, red, orange, yellow, and peach. The color shades are almost all unique to Christensen (no other company produced peach). Occasionally, the base color will be very bright or "electric."

Striped Opaque/Striped Transparent

Christensen Agate Company Striped Opaques and Striped Transparents are single or double seamed. They have a colored base with one of more opaque colors striped or banded across the surface from seam to seam. Rarely will the base color be an "electric" color, as opposed to the striping color, which often can be "electric." Usually the striping color is contrasting to the base color. In some cases, the striping color will be a different shade of the base color. This is rare.

Swirls

Christensen Agate Swirls are two or more colors mixed together in a single furnace pot.

Examples with as many as five colors are known to exist. Transparent base swirls are rarer than opaque base swirls. Generally, Christensen Agate did not use a transparent clear; examples in transparent clear, or with transparent clear as a swirl color, are very rare. Transparent base swirls are much more difficult to find than opaque base swirls. They are also more limited in their color combinations. There is a much wider array of colors in the opaque base swirls.

Because the glass used had varying densities, marble patterns could be created that had various strata or layers. Some collectors have attributed this to chance, but it was actually the result of mixing by an experienced glassworker. These strata appear in the marble as flames, hence the name "Flame Swirl." Examples have been found with anywhere from several flames to two-dozen flames on one marble.

Several types of swirls were marketed by the company under specific names. "Bloodies" are an opaque white base with transparent red and translucent brown swirls. "American Agates" are an opaque white to opalescent white base with a swirl that ranges from translucent electric red to transparent electric orange.

There are also a variety of names that have been thought up by collectors. "Diaper-fold" refers to a swirl that is a single seam pattern.

When viewed from the side, the swirl pattern looks like a diaper on a baby. "Turkey" is a swirl pattern that looks like the head of a turkey with a long wattle hanging down from its beak. "Layered sand" has strata that are finer than most flames and resembles layers of sand in an aquarium or in sand art containers. There are a wide variety of names applied by collectors that describe various color combinations. I have noted these in the pictures where applicable.

Guineas and Cobras

Long considered one of the "holy grails" of marble collecting, the Christensen Agate Guinea and Christensen Agate Cobra have taken on an almost mythic quality.

Guineas have a transparent base with flecks of opaque colors melted to the surface. Cobras (sometimes called Cyclones) are transparent with the flecks of color as a ribbon or core inside the marble. The name "World's Best Guineas" derives from the resemblance of the marble to the necks of guinea hens that roamed the company grounds. Cobras or Cyclones were originally called by the latter name by the company, presumably because the core looked like

a twister. The former name is more recent, probably deriving from the coloring found on the necks of some Cobra snakes, although some collectors have speculated that it was a name meant to strike awe in an opponent in the marble ring.

The Guinea's base color is clear, blue or amber. Red and green have been reported, although I have never seen a genuine Guinea marble or a picture of a genuine Guinea marble with this color base. The marble can be either single or double seam. The surface has splotches and/or stretched flecks of various colors including any combination of light blue, light green, yellow, electric, orange, lavender, black, and white. I have seen examples with as few as one color and as many as six colors. As little as less than ten percent, to almost the entire surface, can be covered by the colored flecks. Cobras have slightly different color combination. Almost all Cobras are clear base. Generally, only two colors are found inside the marble, although occasionally there are more. Some Guineas have colored flecks inside the marble, as well as outside the marble. These are called Guinea-Cobras by collectors.

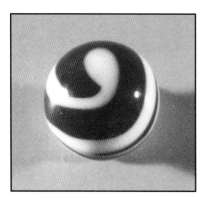

Christensen Agate Company. Hand-gathered, 5/8". Estimate of value: $400 to $800. *Courtesy of Stanley Block.*

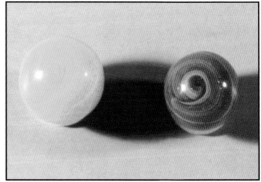

Christensen Agate Company. Hand-gathered, 5/8". Estimate of value: $400 to $800. *Courtesy of Stanley Block.*

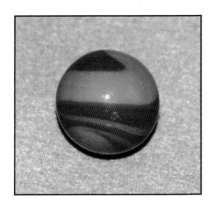

Christensen Agate Company. Hand-gathered, 27/32". Estimate of value: $500 to $1,000. *Courtesy of Charley Hix, Jr.*

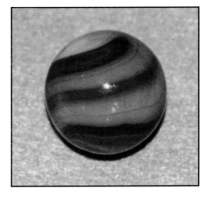

Christensen Agate Company. Hand-gathered, 27/32". Estimate of value: $500 to $1,000. *Courtesy of Charley Hix, Jr.*

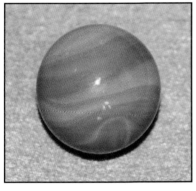

Christensen Agate Company. Hand-gathered, 27/32". Estimate of value: $500 to $1,000. *Courtesy of Charley Hix, Jr.*

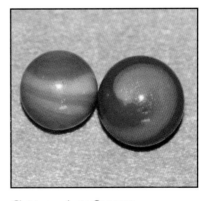

Christensen Agate Company. Hand-gathered, 5/8" & 21/32". *Courtesy of Charley Hix, Jr.*

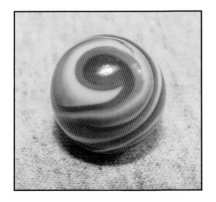

Christensen Agate Company. Hand-gathered, 21/32". Estimate of value: $400 to $800. *Courtesy of Ken Humphrey.*

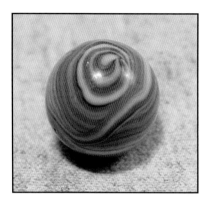

Christensen Agate Company. Hand-gathered, 5/8". Estimate of value: $300 to $600. *Courtesy of Bill Tow.*

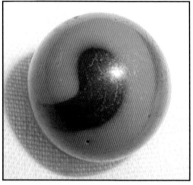

Christensen Agate Company. Hand-gathered, 21/32". Estimate of value: $300 to $600. *Courtesy of Charley Hix, Jr.*

Christensen Agate Company. Hand-gathered, 11/16". Estimate of value: $300 to $600. *Courtesy of Charley Hix, Jr.*

Christensen Agate Company. Hand-gathered, 23/32". Top view. Estimate of value: $300 to $600. *Courtesy of Charley Hix, Jr.*

Christensen Agate Company. Hand-gathered, 23/32". Side view. Estimate of value: $300 to $600. *Courtesy of Charley Hix, Jr.*

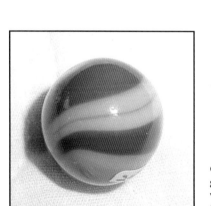

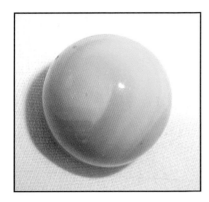

Christensen Agate Company. Hand-gathered, 23/32". Estimate of value: $300 to $600. *Courtesy of Charley Hix, Jr.*

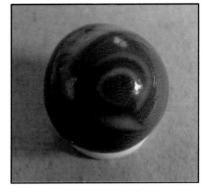

Christensen Agate Company. Hand-gathered, 23/32". Estimate of value: $300 to $600. *Courtesy of Stanley Block.*

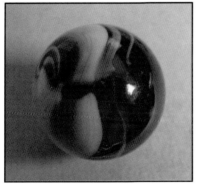

Christensen Agate Company. Hand-gathered, 1-1/4". Estimate of value: $1,000 to $1,500. *Courtesy of Robert Block.*

Christensen Agate Company. Hand-gathered. Assorted, 21/32" to 25/32". *Courtesy of Charley Hix, Jr.*

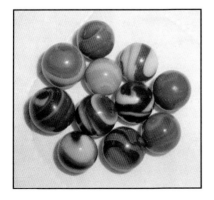

Christensen Agate Company. Hand-gathered. Assorted, 21/32" to 25/32". *Courtesy of Charley Hix, Jr.*

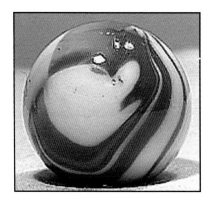

Christensen Agate Company. American Agate, 11/16". Estimate of value: $50 to $100. *Courtesy of The AuctionBlocks.*

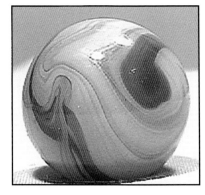

Christensen Agate Company. American Agate, 11/16". Estimate of value: $50 to $100. *Courtesy of The AuctionBlocks.*

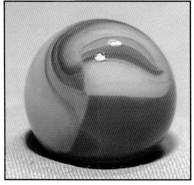

Christensen Agate Company. American Agate, 11/16". Estimate of value: $50 to $100. *Courtesy of The AuctionBlocks.*

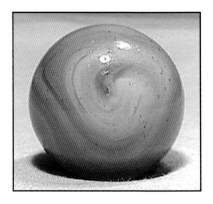

Christensen Agate Company. American Agate, 11/16". Estimate of value: $50 to $100. *Courtesy of The AuctionBlocks.*

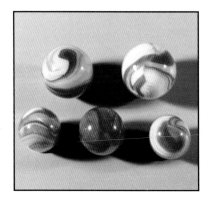

Christensen Agate Company. American Agate, 5/8" to 15/16". *Courtesy of Stanley Block.*

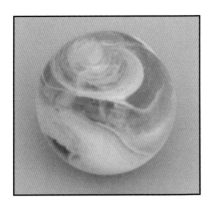

Christensen Agate Company. Slag, 3/4".
Estimate of value: $40 to $80. *Courtesy of
Stanley Block.*

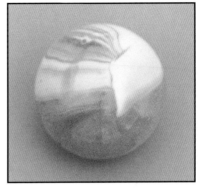

Christensen Agate Company. Slag (electric),
15/16". Estimate of value: $300 to $600.
Courtesy of Stanley Block.

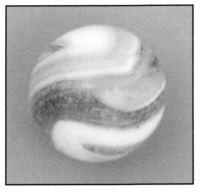

Christensen Agate Company. Slag (electric),
11/16". Estimate of value: $75 to $150.
Courtesy of Stanley Block.

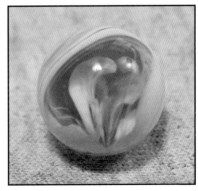

Christensen Agate Company. Slag (electric),
21/32". Estimate of value: $75 to $150.
Courtesy of Bill Tow.

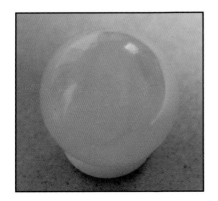

Christensen Agate Company. Moonie (blue), 21/32".
Estimate of value: $500 to $750. *Courtesy of Stanley Block.*

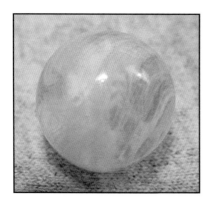

Christensen Agate Company. Slag (electric), 5/8". Estimate of value: $75 to $150.
Courtesy of Kenn Fung.

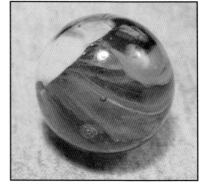

Christensen Agate Company. Slag (peach), 15/16". Estimate of value: $600 to $1,200.
Courtesy of Les Jones.

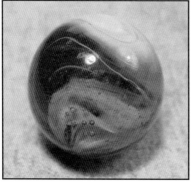

Christensen Agate Company. Slag (peach), 15/16". Estimate of value: $600 to $1,200.
Courtesy of Les Jones.

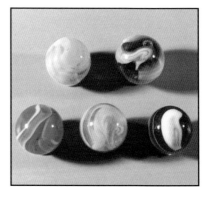

Christensen Agate Company. Slag. Assorted, 11/16". *Courtesy of Stanley Block.*

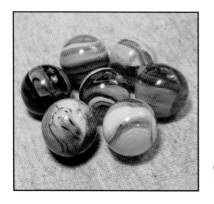

Christensen Agate Company. Slag. Assorted, 19/32" to 21/32". *Courtesy of Bill Tow.*

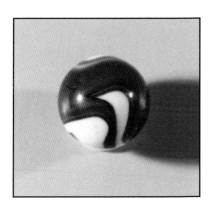

Christensen Agate Company. Swirl. Bloodie, 5/8". Estimate of value: $40 to $80. *Courtesy of Stanley Block.*

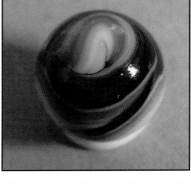

Christensen Agate Company. Swirl. Bloodie, 21/32". Estimate of value: $40 to $80. *Courtesy of The AuctionBlocks.*

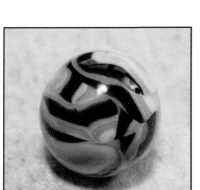

Christensen Agate Company. Swirl, 21/32". Estimate of value: $300 to $600. *Courtesy of Bill Tow.*

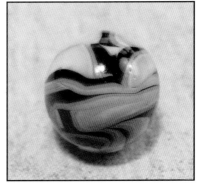

Christensen Agate Company. Swirl, 21/32". Estimate of value: $300 to $600. *Courtesy of Bill Tow.*

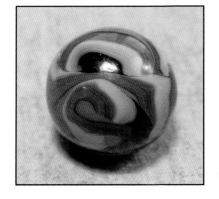

Christensen Agate Company. Swirl, 7/8". Estimate of value: $750 to $1,250. *Courtesy of Bill Tow.*

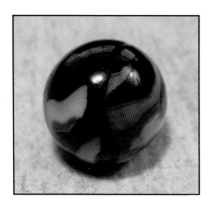

Christensen Agate Company. Swirl, 7/8". Estimate of value: $750 to $1,250. *Courtesy of Bill Tow.*

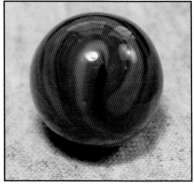

Christensen Agate Company. Swirl, 11/16". Estimate of value: $125 to $250. *Courtesy of Bill Tow.*

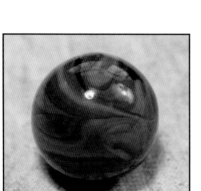

Christensen Agate Company. Swirl, 11/16". Estimate of value: $125 to $250. *Courtesy of Bill Tow.*

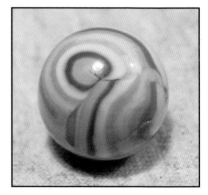

Christensen Agate Company. Swirl, 11/16". Estimate of value: $175 to $350. *Courtesy of Bill Tow.*

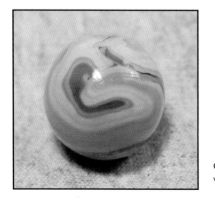

Christensen Agate Company. Swirl, 11/16". Estimate of value: $175 to $350. *Courtesy of Bill Tow.*

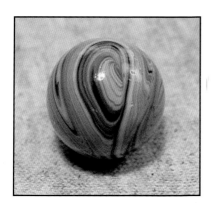

Christensen Agate Company. Swirl, 5/8". Estimate of value: $150 to $300. *Courtesy of Alan Dair.*

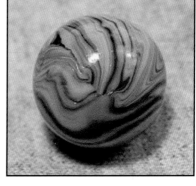

Christensen Agate Company. Swirl, 5/8". Estimate of value: $150 to $300. *Courtesy of Alan Dair.*

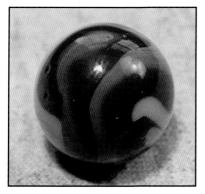

Christensen Agate Company. Swirl, 21/32". Estimate of value: $200 to $400. *Courtesy of Kenn Fung.*

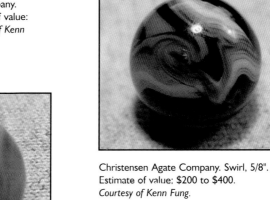

Christensen Agate Company. Swirl, 5/8". Estimate of value: $200 to $400. *Courtesy of Kenn Fung.*

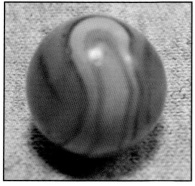

Christensen Agate Company. Swirl, 5/8". Estimate of value: $150 to $300. *Courtesy of Kenn Fung.*

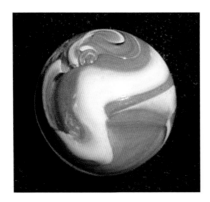

Christensen Agate Company. Swirl, 5/8". Estimate of value: $250 to $500. *Courtesy of Rich Stremme.*

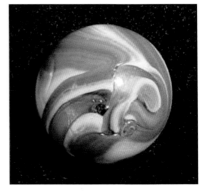

Christensen Agate Company. Swirl, 5/8". Estimate of value: $250 to $500. *Courtesy of Rich Stremme.*

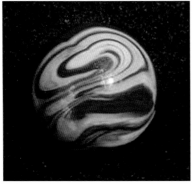

Christensen Agate Company. Swirl, 5/8". Estimate of value: $150 to $300. *Courtesy of Rich Stremme.*

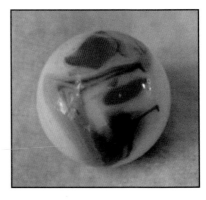

Christensen Agate Company. Swirl, 5/8". Estimate of value: $200 to $400. *Courtesy of Bill Tow.*

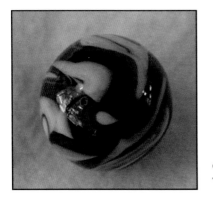

Christensen Agate Company. Swirl, 5/8". Estimate of value: $200 to $400. *Courtesy of Bill Tow.*

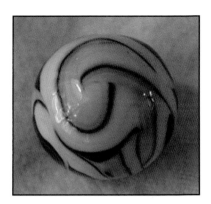

Christensen Agate Company. Swirl, 5/8". Estimate of value: $100 to $200. *Courtesy of Bill Tow.*

Christensen Agate Company. Swirl, 5/8". Estimate of value: $200 to $400. *Courtesy of Bill Tow.*

Christensen Agate Company. Swirl, 5/8". Estimate of value: $300 to $600. *Courtesy of Bill Tow.*

Christensen Agate Company. Swirl, 5/8". Estimate of value: $200 to $400. *Courtesy of Bill Tow.*

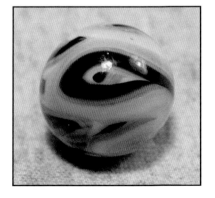

Christensen Agate Company. Swirl, 21/32". Estimate of value: $300 to $600. *Courtesy of Bill Tow.*

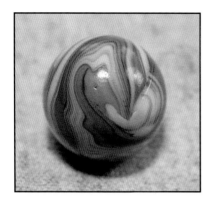

Christensen Agate Company. Swirl , 5/8". Estimate of value: $275 to $550. *Courtesy of Bill Tow.*

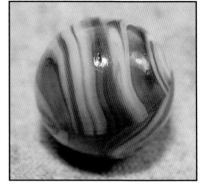

Christensen Agate Company. Swirl, 5/8". Estimate of value: $275 to $550. *Courtesy of Bill Tow.*

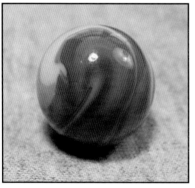

Christensen Agate Company. Swirl (Triple Turkey Head), 5/8". Estimate of value: $150 to $300. *Courtesy of Kenn Fung.*

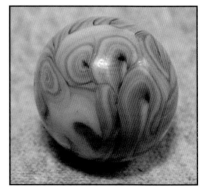

Christensen Agate Company. Swirl (Multiple Turkey Heads), 21/32". Estimate of value: $350 to $700. *Courtesy of Ken Humphrey.*

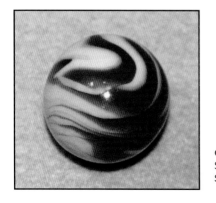

Christensen Agate Company. Flame Swirl, 5/8". Estimate of value: $250 to $500. *Courtesy of Stanley Block.*

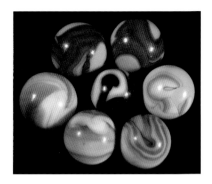

Christensen Agate Company. Two-color Swirls. 19/32" to 21/32". *Courtesy of Bill Tow and Rich Stremme. (Photo courtsy of Bill Tow.)*

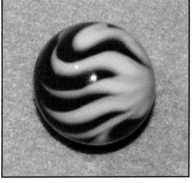

Christensen Agate Company. Flame Swirl, 5/8". Estimate of value: $300 to $600. *Courtesy of Stanley Block.*

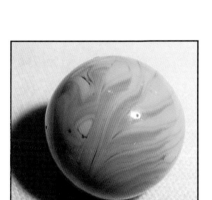

Christensen Agate Company. Flame Swirl, 5/8". Estimate of value: $300 to $600. *Courtesy of Bruce Bruchac.*

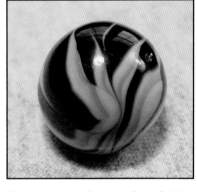

Christensen Agate Company. Flame Swirl, 11/16". Estimate of value: $400 to $800. *Courtesy of Ken Humphrey.*

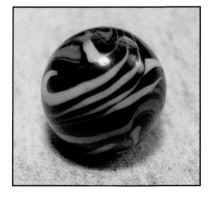

Christensen Agate Company. Flame Swirl, 11/16". Estimate of value: $400 to $800. *Courtesy of Ken Humphrey.*

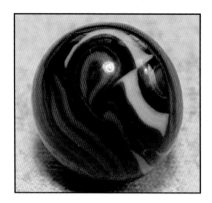

Christensen Agate Company. Flame Swirl, 11/16". Estimate of value: $400 to $800. *Courtesy of Ken Humphrey.*

Christensen Agate Company. Flame Swirl, 21/32". Estimate of value: $250 to $500. *Courtesy of Ken Humphrey.*

Christensen Agate Company. Flame Swirl, 21/32". Estimate of value: $250 to $500. *Courtesy of Ken Humphrey.*

Christensen Agate Company. Flame Swirl, 5/8". Estimate of value: $250 to $500. *Courtesy of Ken Humphrey.*

Christensen Agate Company. Flame Swirl, 5/8". Estimate of value: $250 to $500. *Courtesy of Ken Humphrey.*

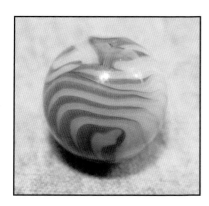

Christensen Agate Company. Flame Swirl, 21/32". Estimate of value: $400 to $750. *Courtesy of Bill Tow.*

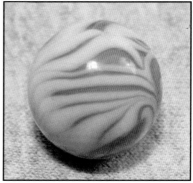

Christensen Agate Company. Flame Swirl, 21/32". Estimate of value: $400 to $750. *Courtesy of Bill Tow.*

Christensen Agate Company. Flame Swirl, 5/8". Estimate of value: $400 to $750. *Courtesy of Bill Tow.*

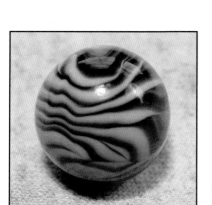

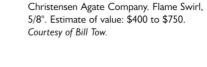

Christensen Agate Company. Flame Swirl, 5/8". Estimate of value: $400 to $750. *Courtesy of Bill Tow.*

Christensen Agate Company. Flame Swirl, 21/32". Estimate of value: $400 to $800. *Courtesy of Bill Tow.*

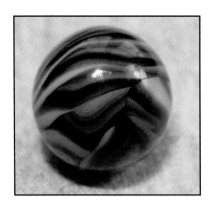

Christensen Agate Company. Flame Swirl, 21/32". Estimate of value: $400 to $800. *Courtesy of Bill Tow.*

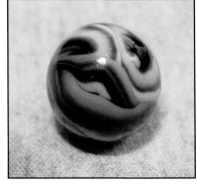

Christensen Agate Company. Flame Swirl, 21/32". Estimate of value: $300 to $600. *Courtesy of Bill Tow.*

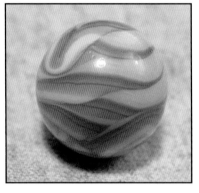

Christensen Agate Company. Flame Swirl, 21/32". Estimate of value: $350 to $700. *Courtesy of Bill Tow.*

Christensen Agate Company. Flame Swirl, 21/32". Estimate of value: $350 to $750. *Courtesy of Bill Tow.*

Christensen Agate Company. Flame Swirl, 13/16". Estimate of value: $750 to $1,250. *Courtesy of Bill Tow.*

Christensen Agate Company. Flame Swirl, 13/16". Estimate of value: $750 to $1,250. *Courtesy of Bill Tow.*

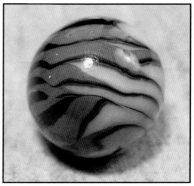

Christensen Agate Company. Flame Swirl, 21/32". Estimate of value: $750 to $1,250. *Courtesy of Peter Sharrer.*

Christensen Agate Company. Flame Swirl, 21/32". Estimate of value: $750 to $1,250. *Courtesy of Peter Sharrer.*

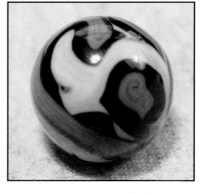

Christensen Agate Company. Flame Swirl, 21/32". Estimate of value: $750 to $1,250. *Courtesy of Peter Sharrer.*

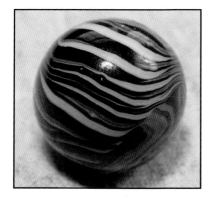

Christensen Agate Company. Flame Swirl, 11/16". Estimate of value: $750 to $1,250. *Courtesy of Peter Sharrer.*

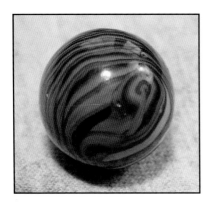

Christensen Agate Company. Flame Swirl, 11/16". Estimate of value: $400 to $800. *Courtesy of Peter Sharrer.*

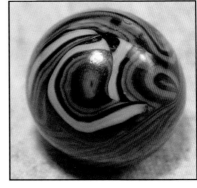

Christensen Agate Company. Flame Swirl, 11/16". Estimate of value: $400 to $800. *Courtesy of Peter Sharrer.*

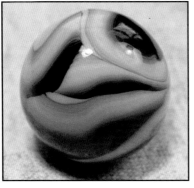

Christensen Agate Company. Flame Swirl, 21/32". Estimate of value: $250 to $500. *Courtesy of Les Jones.*

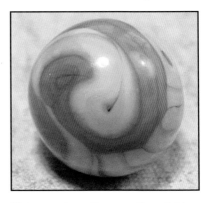

Christensen Agate Company. Flame Swirl, 21/32". Estimate of value: $300 to $600. *Courtesy of Les Jones.*

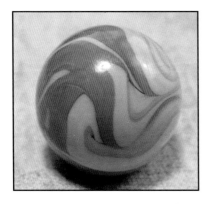

Christensen Agate Company. Flame Swirl, 21/32". Estimate of value: $300 to $600. *Courtesy of Les Jones.*

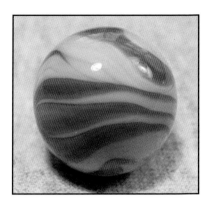

Christensen Agate Company. Flame Swirl, 21/32". Estimate of value: $250 to $500. *Courtesy of Les Jones.*

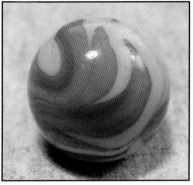

Christensen Agate Company. Flame Swirl, 21/32". Estimate of value: $250 to $500. *Courtesy of Les Jones.*

Christensen Agate Company. Flame Swirl, 21/32". Estimate of value: $250 to $500. *Courtesy of Les Jones.*

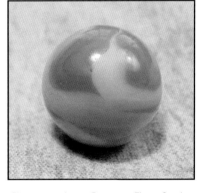

Christensen Agate Company. Flame Swirl, 21/32". Estimate of value: $250 to $500. *Courtesy of Les Jones.*

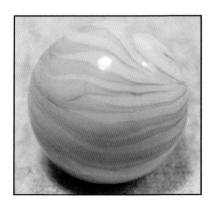

Christensen Agate Company. Flame Swirl, 21/32". Estimate of value: $250 to $500. *Courtesy of Les Jones.*

Christensen Agate Company 99

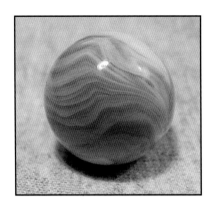

Christensen Agate Company. Flame Swirl, 21/32". Estimate of value: $250 to $500. *Courtesy of Les Jones.*

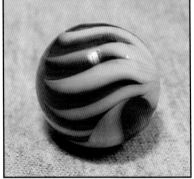

Christensen Agate Company. Flame Swirl, 21/32". Estimate of value: $250 to $500. *Courtesy of Les Jones.*

Christensen Agate Company. Flame Swirl, 21/32". Estimate of value: $250 to $500. *Courtesy of Les Jones.*

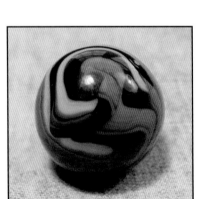

Christensen Agate Company. Flame Swirl, 21/32". Estimate of value: $400 to $800. *Courtesy of Les Jones.*

Christensen Agate Company. Flame Swirl, 21/32". Estimate of value: $400 to $800. *Courtesy of Les Jones.*

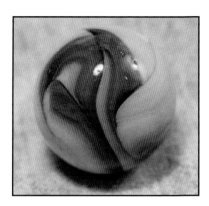

Christensen Agate Company. Flame Swirl, 5/8". Estimate of value: $350 to $700. *Courtesy of Steve Campbell.*

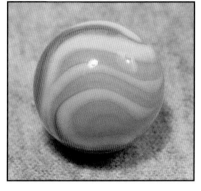

Christensen Agate Company. Flame Swirl, 5/8". Estimate of value: $300 to $600. *Courtesy of Steve Campbell.*

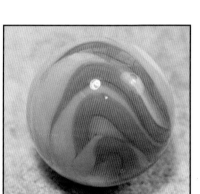

Christensen Agate Company. Flame Swirl, 5/8". Estimate of value: $300 to $600. *Courtesy of Steve Campbell.*

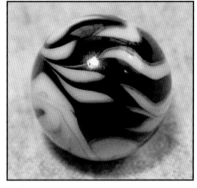

Christensen Agate Company. Flame Swirl, 5/8". Estimate of value: $350 to $700. *Courtesy of Steve Campbell.*

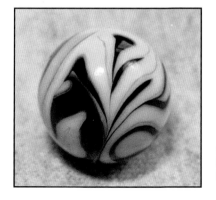

Christensen Agate Company. Flame Swirl, 5/8". Estimate of value: $350 to $700. *Courtesy of Steve Campbell.*

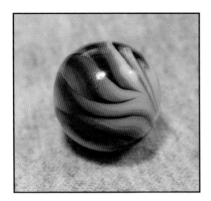

Christensen Agate Company. Flame Swirl, 5/8". Estimate of value: $250 to $500. *Courtesy of Kenn Fung.*

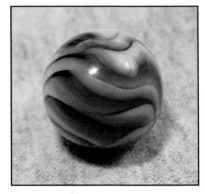

Christensen Agate Company. Flame Swirl, 5/8". Estimate of value: $250 to $500. *Courtesy of Kenn Fung.*

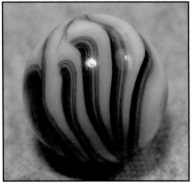

Christensen Agate Company. Flame Swirl, 11/16". Estimate of value: $400 to $750. *Courtesy of Alan Dair.*

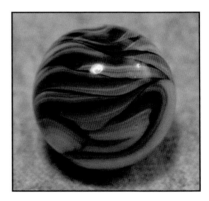

Christensen Agate Company. Flame Swirl, 11/16". Estimate of value: $400 to $750. *Courtesy of Alan Dair.*

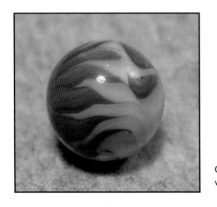

Christensen Agate Company. Flame Swirl, 5/8". Estimate of value: $250 to $500. *Courtesy of Alan Dair.*

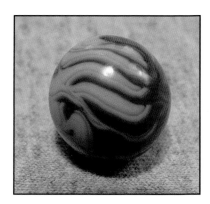

Christensen Agate Company. Flame Swirl,
5/8". Estimate of value: $250 to $500.
Courtesy of Alan Dair.

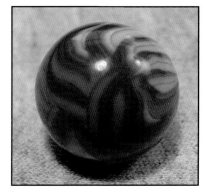

Christensen Agate Company. Flame Swirl,
5/8". Estimate of value: $250 to $500.
Courtesy of Alan Dair.

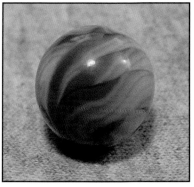

Christensen Agate Company. Flame Swirl,
5/8". Estimate of value: $250 to $500.
Courtesy of Alan Dair.

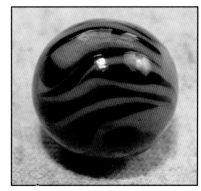

Christensen Agate Company. Flame Swirl,
5/8". Estimate of value: $250 to $500.
Courtesy of Alan Dair.

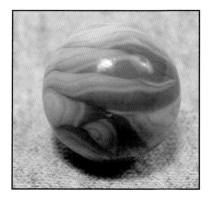

Christensen Agate Company. Flame Swirl, 5/8". Estimate of
value: $250 to $500. *Courtesy of Alan Dair.*

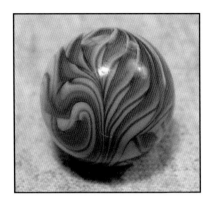

Christensen Agate Company. Flame Swirl, 5/8". Estimate of value: $300 to $600. *Courtesy of Alan Dair.*

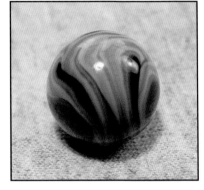

Christensen Agate Company. Flame Swirl, 5/8". Estimate of value: $250 to $500. *Courtesy of Alan Dair.*

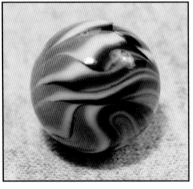

Christensen Agate Company. Flame Swirl, 5/8". Estimate of value: $250 to $500. *Courtesy of Alan Dair.*

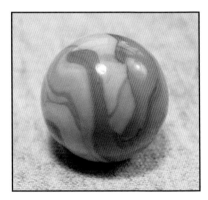

Christensen Agate Company. Flame Swirl, 5/8". Estimate of value: $250 to $500. *Courtesy of Kenn Fung.*

Christensen Agate Company. Flame Swirl, 5/8". Estimate of value: $250 to $500. *Courtesy of Kenn Fung.*

Christensen Agate Company. Flame Swirl, 5/8". Estimate of value: $300 to $600. *Courtesy of Kenn Fung.*

Christensen Agate Company. Flame Swirl, 5/8". Estimate of value: $300 to $600. *Courtesy of Kenn Fung.*

Christensen Agate Company. Flame Swirl, 5/8". Estimate of value: $350 to $700. *Courtesy of Kenn Fung.*

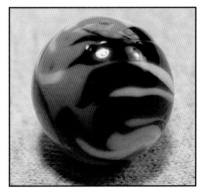

Christensen Agate Company. Flame Swirl, 5/8". Estimate of value: $350 to $700. *Courtesy of Kenn Fung.*

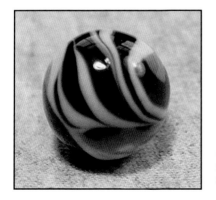

Christensen Agate Company. Flame Swirl, 5/8". Estimate of value: $350 to $700. *Courtesy of Kenn Fung.*

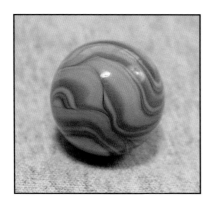

Christensen Agate Company. Flame Swirl, 5/8". Estimate of value: $250 to $500. *Courtesy of Kenn Fung.*

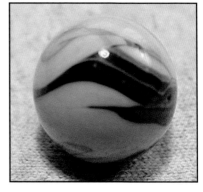

Christensen Agate Company. Flame Swirl, 5/8". Estimate of value: $250 to $500. *Courtesy of Kenn Fung.*

Christensen Agate Company. Flame Swirl, 5/8". Estimate of value: $250 to $500. *Courtesy of Kenn Fung.*

Christensen Agate Company. Flame Swirl, 5/8". Estimate of value: $250 to $500. *Courtesy of Kenn Fung.*

Christensen Agate Company. Flame Swirl, 5/8". Estimate of value: $250 to $500. *Courtesy of Kenn Fung.*

Christensen Agate Company. Flame Swirl, 5/8". Estimate of value: $400 to $600. *Courtesy of Kenn Fung.*

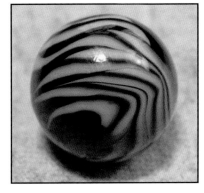

Christensen Agate Company. Flame Swirl, 5/8". Estimate of value: $400 to $600. *Courtesy of Kenn Fung.*

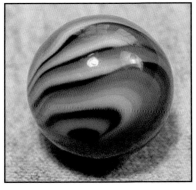

Christensen Agate Company. Flame Swirl, 5/8". Estimate of value: $250 to $500. *Courtesy of Kenn Fung.*

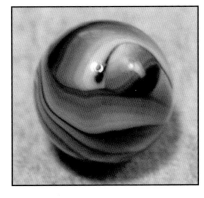

Christensen Agate Company. Flame Swirl, 5/8". Estimate of value: $250 to $500. *Courtesy of Kenn Fung.*

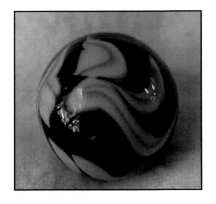

Christensen Agate Company. Flame Swirl, 5/8". Estimate of value: $250 to $500. *Courtesy of Bill Tow.*

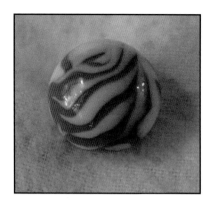

Christensen Agate Company. Flame Swirl, 5/8". Estimate of value: $300 to $600. *Courtesy of Bill Tow.*

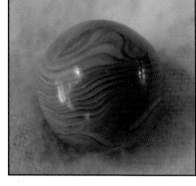

Christensen Agate Company. Flame Swirl, 5/8". Estimate of value: $400 to $800. *Courtesy of Bill Tow.*

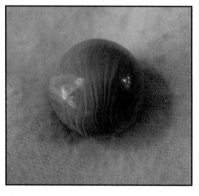

Christensen Agate Company. Flame Swirl, 5/8". Estimate of value: $400 to $800. *Courtesy of Bill Tow.*

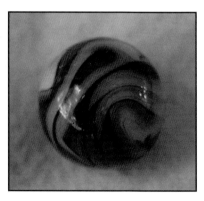

Christensen Agate Company. Flame Swirl, 5/8". Estimate of value: $250 to $500. *Courtesy of Bill Tow.*

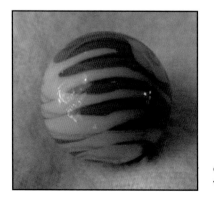

Christensen Agate Company. Flame Swirl, 5/8". Estimate of value: $400 to $800. *Courtesy of Royal Morse III.*

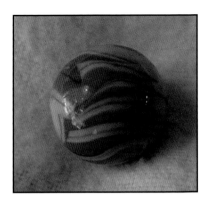

Christensen Agate Company. Flame Swirl, 5/8". Estimate of value: $400 to $800. *Courtesy of Royal Morse III.*

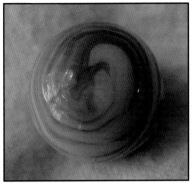

Christensen Agate Company. Flame Swirl, 5/8". Estimate of value: $250 to $500. *Courtesy of Bill Tow.*

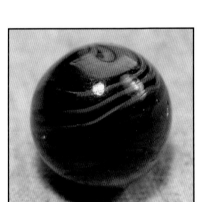

Christensen Agate Company. Flame Swirl (Blue Ray), 19/32". Estimate of value: $1,000 to $1,750. *Courtesy of Bill Tow.*

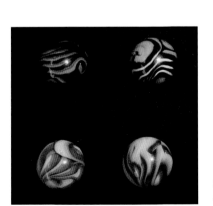

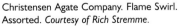

Christensen Agate Company. Flame Swirl (Blue Ray), 19/32". Estimate of value: $1,000 to $1,750. *Courtesy of Bill Tow.*

Christensen Agate Company. Flame Swirl. Assorted. *Courtesy of Rich Stremme.*

Christensen Agate Company 109

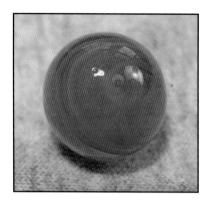

Christensen Agate Company. Transparent Swirl (electric), 5/8". Estimate of value: $300 to $600. *Courtesy of Bill Tow.*

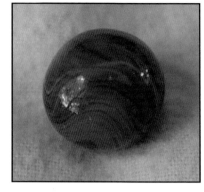

Christensen Agate Company. Transparent Swirl (electric), 5/8". Estimate of value: $300 to $600. *Courtesy of Bill Tow.*

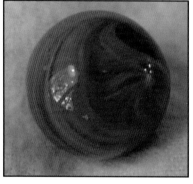

Christensen Agate Company. Transparent Swirl (electric), 5/8". Estimate of value: $300 to $600. *Courtesy of Bill Tow.*

Christensen Agate Company. Transparent Swirl (electric), 5/8". Estimate of value: $300 to $600. *Courtesy of Bill Tow.*

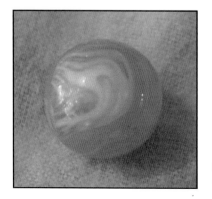

Christensen Agate Company. Transparent Swirl (electric), 5/8". Estimate of value: $300 to $600. *Courtesy of Bill Tow.*

Christensen Agate Company. Transparent Swirl (electric), 5/8". Estimate of value: $300 to $600. *Courtesy of Bill Tow.*

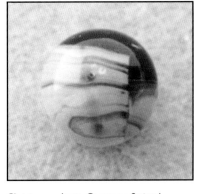

Christensen Agate Company. Striped Transparent, 19/32". Estimate of value: $275 to $550. *Courtesy of Stanley Block.*

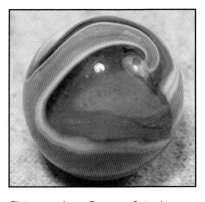

Christensen Agate Company. Striped Transparent, 21/32". Estimate of value: $450 to $800. *Courtesy of Peter Sharrer.*

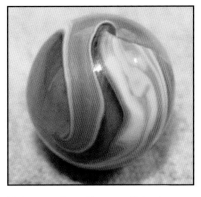

Christensen Agate Company. Striped Transparent, 21/32". Estimate of value: $450 to $800. *Courtesy of Peter Sharrer.*

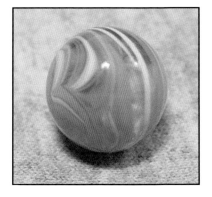

Christensen Agate Company. Striped Transparent, 5/8". Estimate of value: $150 to $300. *Courtesy of Peter Sharrer.*

Christensen Agate Company. Striped Transparent, 5/8". Estimate of value: $150 to $300. *Courtesy of Peter Sharrer.*

Christensen Agate Company. Striped Transparent, 5/8". Estimate of value: $150 to $300. *Courtesy of Peter Sharrer.*

Christensen Agate Company. Striped Transparent, 5/8". Estimate of value: $200 to $400. *Courtesy of Les Jones.*

Christensen Agate Company. Striped Transparent, 5/8". Estimate of value: $150 to $300. *Courtesy of Steve Smith.*

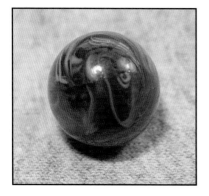

Christensen Agate Company. Striped Transparent, 5/8". Estimate of value: $150 to $300. *Courtesy of Steve Smith.*

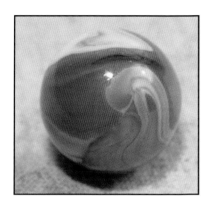

Christensen Agate Company. Striped Transparent, 5/8". Estimate of value: $200 to $400. *Courtesy of Hansel de Sousa.*

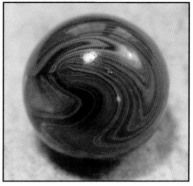

Christensen Agate Company. Striped Transparent, 5/8". Estimate of value: $200 to $400. *Courtesy of Hansel de Sousa.*

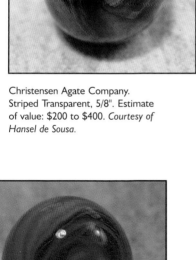

Christensen Agate Company. Striped Transparent, 5/8". Estimate of value: $200 to $400. *Courtesy of Hansel de Sousa.*

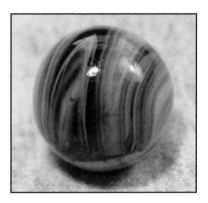

Christensen Agate Company. Striped Transparent, 5/8". Estimate of value: $200 to $400. *Courtesy of Steve Campbell.*

Christensen Agate Company. Striped Transparent, 5/8". Estimate of value: $150 to $300. *Courtesy of Steve Campbell.*

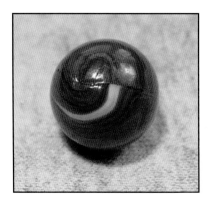

Christensen Agate Company. Striped Transparent, 5/8". Estimate of value: $150 to $300. *Courtesy of Steve Campbell.*

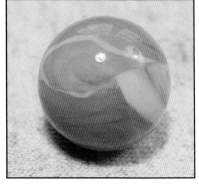

Christensen Agate Company. Striped Transparent, 5/8". Estimate of value: $150 to $300. *Courtesy of Steve Campbell.*

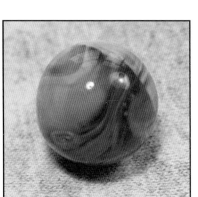

Christensen Agate Company. Striped Transparent, 5/8". Estimate of value: $150 to $300. *Courtesy of Steve Campbell.*

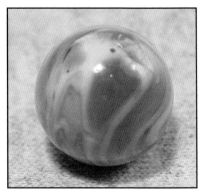

Christensen Agate Company. Striped Transparent, 5/8". Estimate of value: $200 to $400. *Courtesy of Kenn Fung.*

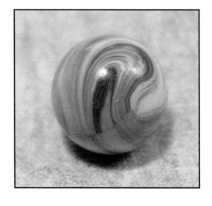

Christensen Agate Company. Striped Transparent, 5/8". Estimate of value: $200 to $400. *Courtesy of Kenn Fung.*

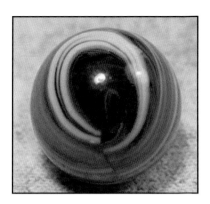

Christensen Agate Company. Striped Transparent, 5/8". Estimate of value: $750 to $1,250. *Courtesy of Kenn Fung.*

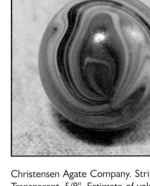

Christensen Agate Company. Striped Transparent, 5/8". Estimate of value: $750 to $1,250. *Courtesy of Kenn Fung.*

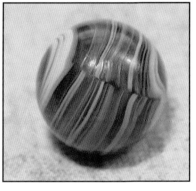

Christensen Agate Company. Striped Transparent, 5/8". Estimate of value: $750 to $1,250. *Courtesy of Kenn Fung.*

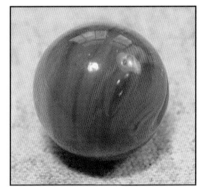

Christensen Agate Company. Striped Transparent, 5/8". Estimate of value: $300 to $600. *Courtesy of Alan Dair.*

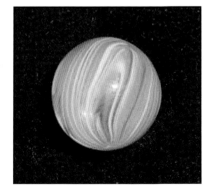

Christensen Agate Company. Striped Transparent, 5/8". Estimate of value: $150 to $300. *Courtesy of Rich Stremme.*

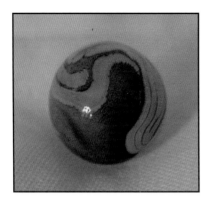

Christensen Agate Company. Striped Transparent, 5/8". Estimate of value: $750 to $1,250. *Courtesy of Bill Tow.*

Christensen Agate Company. Striped Transparent, 5/8". Estimate of value: $750 to $1,250. *Courtesy of Bill Tow.*

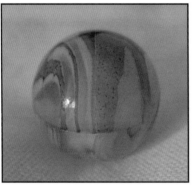

Christensen Agate Company. Striped Transparent, 5/8". Estimate of value: $750 to $1,250. *Courtesy of Bill Tow.*

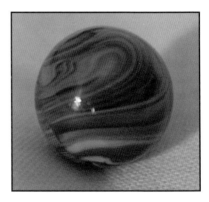

Christensen Agate Company. Striped Transparent, 5/8". Estimate of value: $600 to $1,000. *Courtesy of Bill Tow.*

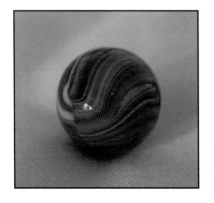

Christensen Agate Company. Striped Transparent, 5/8". Estimate of value: $600 to $1,000. *Courtesy of Bill Tow.*

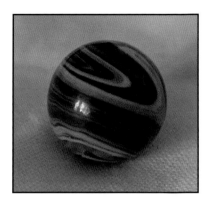

Christensen Agate Company. Striped Transparent, 5/8". Estimate of value: $600 to $1,000. *Courtesy of Bill Tow.*

Christensen Agate Company. Striped Transparent, 5/8". Estimate of value: $600 to $1,000. *Courtesy of Bill Tow.*

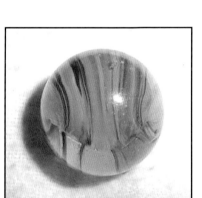

Christensen Agate Company. Striped Transparent, 5/8". Estimate of value: $750 to $1,250. *Courtesy of Bill Tow.*

Christensen Agate Company. Striped Transparent (electric), 5/8". Estimate of value: $300 to $600. *Courtesy of Bill Tow.*

Christensen Agate Company. Striped Transparent (layered sand), 5/8". Estimate of value: $1,000 to $1,750. *Courtesy of Bill Tow.*

Christensen Agate Company. Striped Transparent (submarine), 11/16". Estimate of value: $1,500 to $2,500. *Courtesy of Bill Tow.*

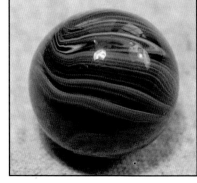

Christensen Agate Company. Striped Transparent (submarine), 11/16". Estimate of value: $1,500 to $2,500. *Courtesy of Bill Tow.*

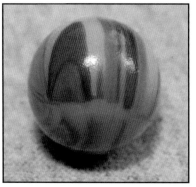

Christensen Agate Company. Striped Opaque, 19/32". Estimate of value: $400 to $800. *Courtesy of Ken Humphrey.*

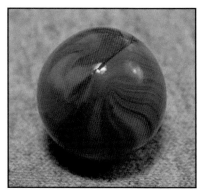

Christensen Agate Company. Striped Opaque, 19/32". Estimate of value: $400 to $800. *Courtesy of Ken Humphrey.*

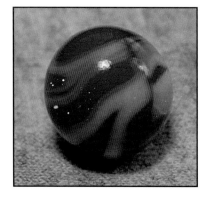

Christensen Agate Company. Striped Opaque, 19/32". Estimate of value: $400 to $800. *Courtesy of Ken Humphrey.*

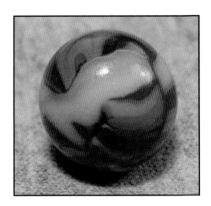

Christensen Agate Company. Striped Opaque, 19/32". Estimate of value: $400 to $800. *Courtesy of Ken Humphrey.*

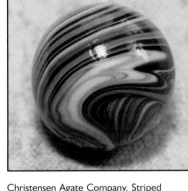

Christensen Agate Company. Striped Opaque, 21/32". Estimate of value: $750 to $1,250. *Courtesy of Bill Tow.*

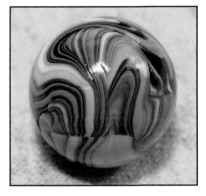

Christensen Agate Company. Striped Opaque, 21/32". Estimate of value: $750 to $1,250. *Courtesy of Bill Tow.*

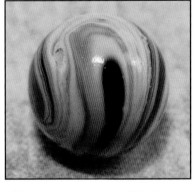

Christensen Agate Company. Striped Opaque, 19/32". Estimate of value: $500 to $800. *Courtesy of Bill Tow.*

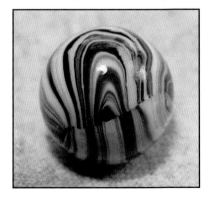

Christensen Agate Company. Striped Opaque, 19/32". Estimate of value: $500 to $800. *Courtesy of Bill Tow.*

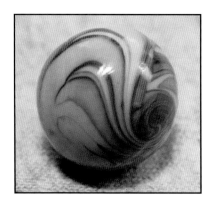

Christensen Agate Company. Striped Opaque, 5/8". Estimate of value: $500 to $800. *Courtesy of Bill Tow.*

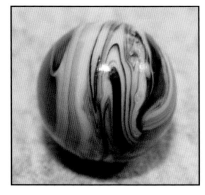

Christensen Agate Company. Striped Opaque, 5/8". Estimate of value: $600 to $1,000. *Courtesy of Bill Tow.*

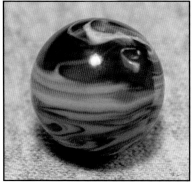

Christensen Agate Company. Striped Opaque, 5/8". Estimate of value: $600 to $1,000. *Courtesy of Bill Tow.*

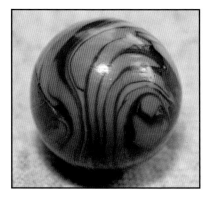

Christensen Agate Company. Striped Opaque, 5/8". Estimate of value: $400 to $750. *Courtesy of Bill Tow.*

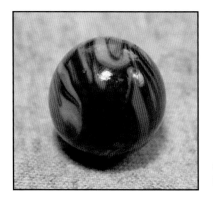

Christensen Agate Company. Striped Opaque, 5/8". Estimate of value: $400 to $750. *Courtesy of Bill Tow.*

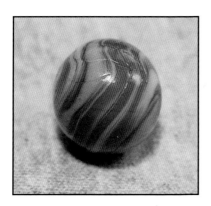

Christensen Agate Company. Striped Opaque, 5/8". Estimate of value: $300 to $600. *Courtesy of Bill Tow.*

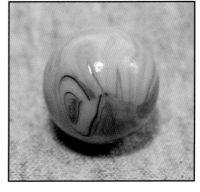

Christensen Agate Company. Striped Opaque, 5/8". Estimate of value: $300 to $600. *Courtesy of Bill Tow.*

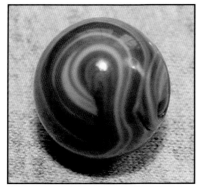

Christensen Agate Company. Striped Opaque (Turkey Head), 5/8". Estimate of value: $400 to $800. *Courtesy of Bill Tow.*

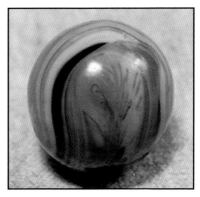

Christensen Agate Company. Striped Opaque, 19/32". Estimate of value: $300 to $600. *Courtesy of Bill Tow.*

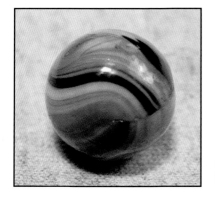

Christensen Agate Company. Striped Opaque, 19/32". Estimate of value: $300 to $600. *Courtesy of Bill Tow.*

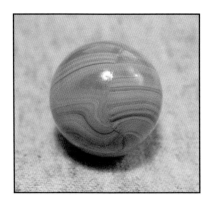

Christensen Agate Company. Striped Opaque, 5/8". Estimate of value: $300 to $600. *Courtesy of Bill Tow.*

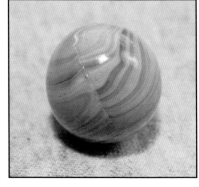

Christensen Agate Company. Striped Opaque, 5/8". Estimate of value: $300 to $600. *Courtesy of Bill Tow.*

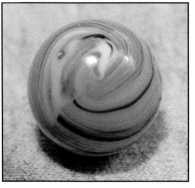

Christensen Agate Company. Striped Opaque, 19/32". Estimate of value: $300 to $600. *Courtesy of Bill Tow.*

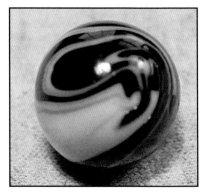

Christensen Agate Company. Striped Opaque, 19/32". Estimate of value: $300 to $600. *Courtesy of Bill Tow.*

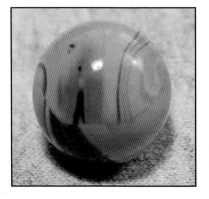

Christensen Agate Company. Striped Opaque, 5/8". Estimate of value: $300 to $600. *Courtesy of Bill Tow.*

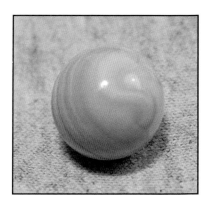

Christensen Agate Company. Striped Opaque, 19/32". Estimate of value: $250 to $500. *Courtesy of Bill Tow.*

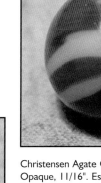

Christensen Agate Company. Striped Opaque, 11/16". Estimate of value: $400 to $750. *Courtesy of Bill Tow.*

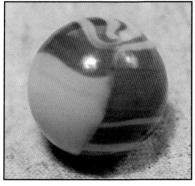

Christensen Agate Company. Striped Opaque, 11/16". Estimate of value: $400 to $750. *Courtesy of Bill Tow.*

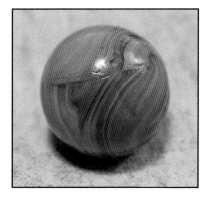

Christensen Agate Company. Striped Opaque, 11/16". Estimate of value: $400 to $750. *Courtesy of Bill Tow.*

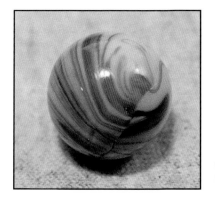

Christensen Agate Company. Striped Opaque, 5/8". Estimate of value: $400 to $750. *Courtesy of Bill Tow.*

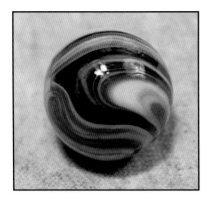

Christensen Agate Company. Striped Opaque, 5/8". Estimate of value: $350 to $700. *Courtesy of Peter Sharrer.*

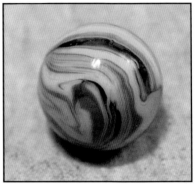

Christensen Agate Company. Striped Opaque, 5/8". Estimate of value: $350 to $700. *Courtesy of Peter Sharrer.*

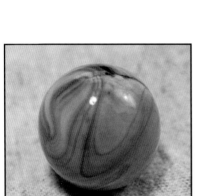

Christensen Agate Company. Striped Opaque, 5/8". Estimate of value: $350 to $700. *Courtesy of Steve Campbell.*

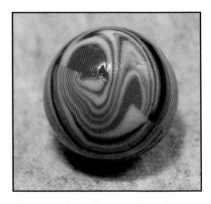

Christensen Agate Company. Striped Opaque, 5/8". Estimate of value: $350 to $700. *Courtesy of Kenn Fung.*

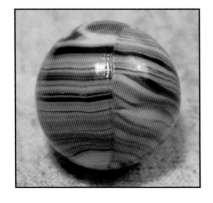

Christensen Agate Company. Striped Opaque, 5/8". Estimate of value: $350 to $700. *Courtesy of Kenn Fung.*

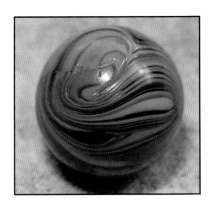

Christensen Agate Company. Striped Opaque, 5/8". Estimate of value: $350 to $700. *Courtesy of Kenn Fung.*

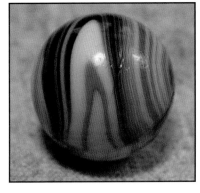

Christensen Agate Company. Striped Opaque, 5/8". Estimate of value: $350 to $700. *Courtesy of Alan Dair.*

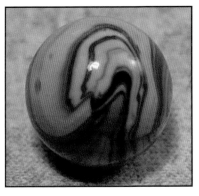

Christensen Agate Company. Striped Opaque, 5/8". Estimate of value: $350 to $700. *Courtesy of Alan Dair.*

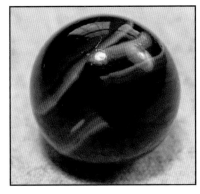

Christensen Agate Company. Striped Opaque, 5/8". Estimate of value: $350 to $700. *Courtesy of Alan Dair.*

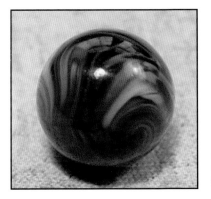

Christensen Agate Company. Striped Opaque, 5/8". Estimate of value: $350 to $700. *Courtesy of Kenn Fung.*

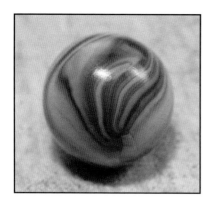

Christensen Agate Company. Striped Opaque, 5/8". Estimate of value: $300 to $600. *Courtesy of Kenn Fung.*

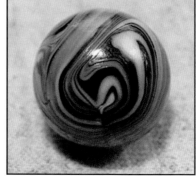

Christensen Agate Company. Striped Opaque, 5/8". Estimate of value: $300 to $600. *Courtesy of Kenn Fung.*

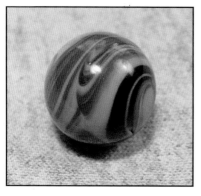

Christensen Agate Company. Striped Opaque, 5/8". Estimate of value: $300 to $600. *Courtesy of Kenn Fung.*

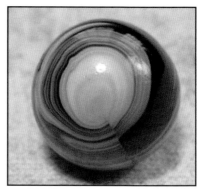

Christensen Agate Company. Striped Opaque, 5/8". Estimate of value: $250 to $500. *Courtesy of Kenn Fung.*

Christensen Agate Company. Striped Opaque, 5/8". Estimate of value: $250 to $500. *Courtesy of Kenn Fung.*

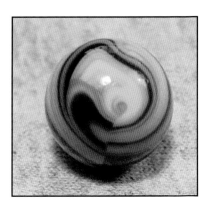

Christensen Agate Company. Striped Opaque, 5/8". Estimate of value: $250 to $500. *Courtesy of Kenn Fung.*

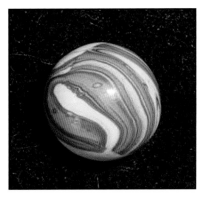

Christensen Agate Company. Striped Opaque, 5/8". Estimate of value: $250 to $500. *Courtesy of Rich Stremme.*

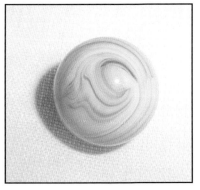

Christensen Agate Company. Striped Opaque, 5/8". Estimate of value: $300 to $600. *Courtesy of Bill Tow.*

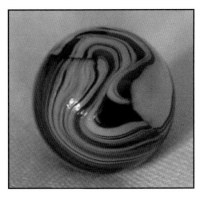

Christensen Agate Company. Striped Transparent, 5/8". Estimate of value: $350 to $700. *Courtesy of Bill Tow.*

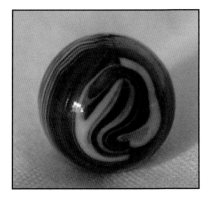

Christensen Agate Company. Striped Transparent, 5/8". Estimate of value: $350 to $700. *Courtesy of Bill Tow.*

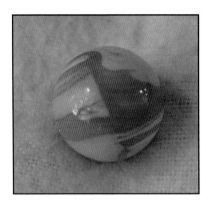

Christensen Agate Company. Striped Opaque, 5/8". Estimate of value: $300 to $600. *Courtesy of Bill Tow.*

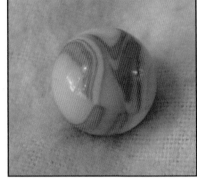

Christensen Agate Company. Striped Opaque, 5/8". Estimate of value: $300 to $600. *Courtesy of Bill Tow.*

Christensen Agate Company. Striped Opaque, 5/8". Estimate of value: $300 to $600. *Courtesy of Bill Tow.*

Christensen Agate Company. Striped Opaque, 5/8". Estimate of value: $300 to $600. *Courtesy of Bill Tow.*

Christensen Agate Company. Striped Opaque, 5/8". Estimate of value: $300 to $600. *Courtesy of Bill Tow.*

Christensen Agate Company. Striped Opaque, 5/8". Estimate of value: $300 to $600. *Courtesy of Bill Tow.*

Christensen Agate Company. Striped Opaque, 5/8". Estimate of value: $250 to $500. *Courtesy of Bill Tow.*

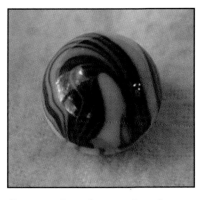

Christensen Agate Company. Striped Opaque, 5/8". Estimate of value: $300 to $600. *Courtesy of Bill Tow.*

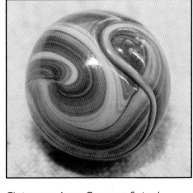

Christensen Agate Company. Striped Opaque, 5/8". Estimate of value: $400 to $800. *Courtesy of Bill Tow.*

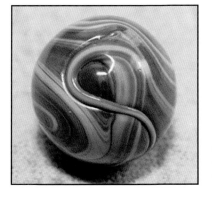

Christensen Agate Company. Striped Opaque, 5/8". Estimate of value: $400 to $800. *Courtesy of Bill Tow.*

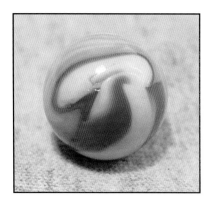

Christensen Agate Company. Striped Opaque, 19/32". Estimate of value: $350 to $600. *Courtesy of Bill Tow.*

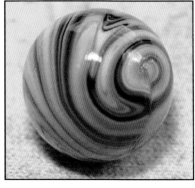

Christensen Agate Company. Striped Opaque, 19/32". Estimate of value: $350 to $600. *Courtesy of Bill Tow.*

Christensen Agate Company. Striped Opaque, 5/8". Estimate of value: $400 to $800. *Courtesy of Bill Tow.*

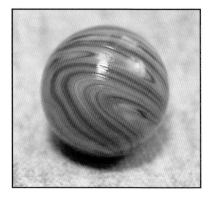

Christensen Agate Company. Striped Opaque, 5/8". Estimate of value: $300 to $600. *Courtesy of Bill Tow.*

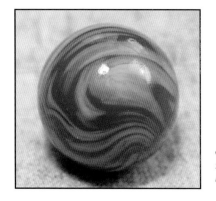

Christensen Agate Company. Striped Opaque , 5/8". Estimate of value: $300 to $600. *Courtesy of Bill Tow.*

Christensen Agate Company. Striped Opaque, 5/8". Estimate of value: $400 to $800. *Courtesy of Bill Tow.*

Christensen Agate Company. Striped Opaque, 21/32". Estimate of value: $400 to $800. *Courtesy of Bill Tow.*

Christensen Agate Company. Striped Opaque, 21/32". Estimate of value: $400 to $800. *Courtesy of Bill Tow.*

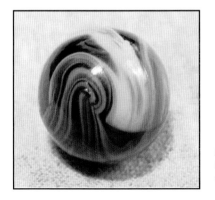

Christensen Agate Company. Striped Opaque, 5/8". Estimate of value: $400 to $800. *Courtesy of Bill Tow.*

Christensen Agate Company. Striped Opaque (electric), 21/32". Estimate of value: $400 to $800. *Courtesy of Bill Tow.*

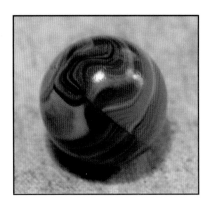

Christensen Agate Company. Striped Opaque (electric), 5/8". Estimate of value: $400 to $800. *Courtesy of Bill Tow.*

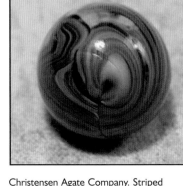

Christensen Agate Company. Striped Opaque (electric), 5/8". Estimate of value: $400 to $800. *Courtesy of Bill Tow.*

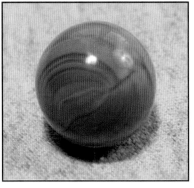

Christensen Agate Company. Striped Opaque (electric), 5/8". Estimate of value: $400 to $800. *Courtesy of Bill Tow.*

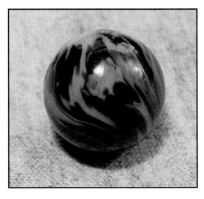

Christensen Agate Company. Striped Opaque (electric), 5/8". Estimate of value: $400 to $800. *Courtesy of Bill Tow.*

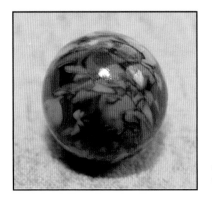

Christensen Agate Company. Guinea Opaque, 5/8". Estimate of value: $750 to $1,250. *Courtesy of Bill Tow.*

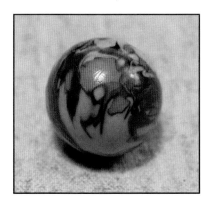

Christensen Agate Company. Guinea Opaque, 19/32". Estimate of value: $800 to $1,500. *Courtesy of Bill Tow.*

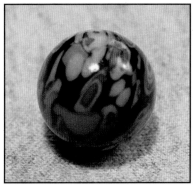

Christensen Agate Company. Guinea Opaque, 5/8". Estimate of value: $800 to $1,500. *Courtesy of Bill Tow.*

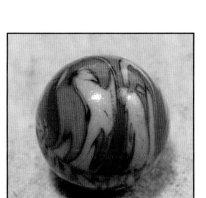

Christensen Agate Company. Guinea Opaque, 5/8". Estimate of value: $800 to $1,500. *Courtesy of Kenn Fung.*

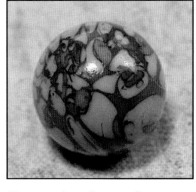

Christensen Agate Company. Guinea Opaque, 5/8". Estimate of value: $750 to $1,250. *Courtesy of Kenn Fung.*

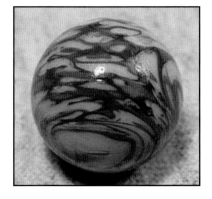

Christensen Agate Company. Guinea Opaque, 5/8". Estimate of value: $750 to $1,250. *Courtesy of Kenn Fung.*

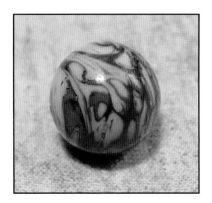

Christensen Agate Company. Guinea Opaque, 5/8". Estimate of value: $750 to $1,250. *Courtesy of Kenn Fung.*

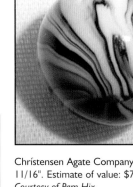

Christensen Agate Company. Guinea Opaque, 11/16". Estimate of value: $750 to $1,500. *Courtesy of Pam Hix.*

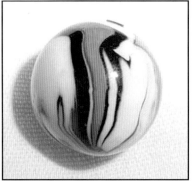

Christensen Agate Company. Guinea Opaque, 11/16". Estimate of value: $750 to $1,500. *Courtesy of Pam Hix.*

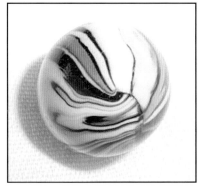

Christensen Agate Company. Guinea Opaque, 11/16". Estimate of value: $750 to $1,500. *Courtesy of Pam Hix.*

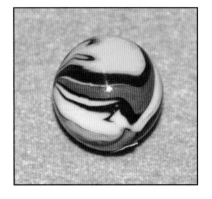

Christensen Agate Company. Guinea Swirl, 5/8". Estimate of value: $750 to $1,500. *Courtesy of Jonathan Hix.*

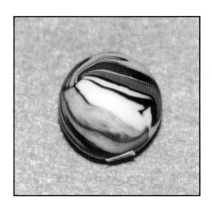

Christensen Agate Company. Guinea Swirl, 21/32". Estimate of value: $600 to $1,250. *Courtesy of Jonathan Hix.*

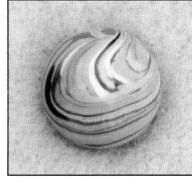

Christensen Agate Company. Guinea Swirl, 21/32". Estimate of value: $600 to $1,250. *Courtesy of Stanley Block.*

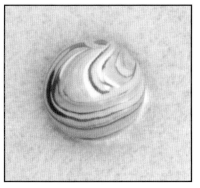

Christensen Agate Company. Guinea Swirl, 21/32". Estimate of value: $600 to $1,250. *Courtesy of Stanley Block.*

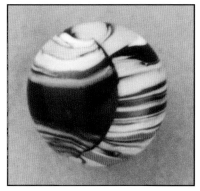

Christensen Agate Company. Guinea, 11/16". Estimate of value: $375 to $750. *Courtesy of Stanley Block.*

Christensen Agate Company. Guinea, 5/8". Estimate of value: $350 to $700. *Courtesy of Stanley Block.*

Christensen Agate Company. Guinea, 5/8". Estimate of value: $350 to $700. *Courtesy of Stanley Block.*

Christensen Agate Company. Guinea, 11/16". Estimate of value: $375 to $750. *Courtesy of Stanley Block.*

Christensen Agate Company. Guinea, 21/32". Estimate of value: $350 to $700. *Courtesy of Stanley Block.*

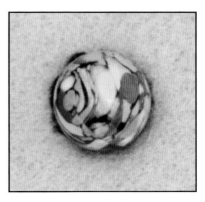

Christensen Agate Company. Guinea, 5/8". Estimate of value: $350 to $700. *Courtesy of Stanley Block.*

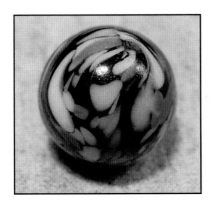

Christensen Agate Company. Guinea, 11/16". Estimate of value: $375 to $750. *Courtesy of Bill Tow.*

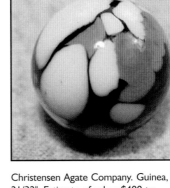

Christensen Agate Company. Guinea, 21/32". Estimate of value: $400 to $800. *Courtesy of Peter Sharrer.*

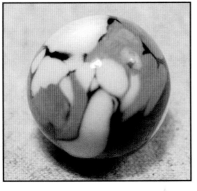

Christensen Agate Company. Guinea, 21/32". Estimate of value: $400 to $800. *Courtesy of Peter Sharrer.*

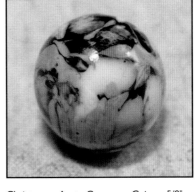

Christensen Agate Company. Guinea, 5/8". Estimate of value: $350 to $700. *Courtesy of Peter Sharrer.*

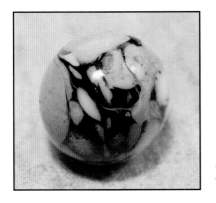

Christensen Agate Company. Guinea, 5/8". Estimate of value: $350 to $700. *Courtesy of Peter Sharrer.*

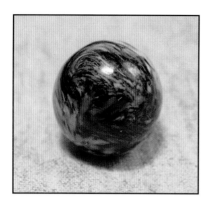

Christensen Agate Company. Guinea, 21/32". Estimate of value: $350 to $700. *Courtesy of Les Jones.*

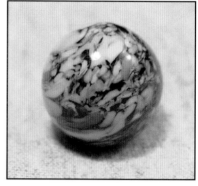

Christensen Agate Company. Guinea, 21/32". Estimate of value: $350 to $700. *Courtesy of Les Jones.*

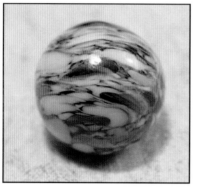

Christensen Agate Company. Guinea, 21/32". Estimate of value: $350 to $700. *Courtesy of Les Jones.*

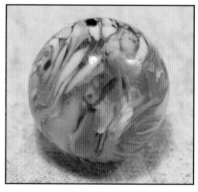

Christensen Agate Company. Guinea, 21/32". Estimate of value: $350 to $700. *Courtesy of Les Jones.*

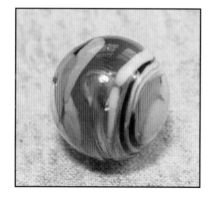

Christensen Agate Company. Guinea, 21/32". Estimate of value: $350 to $700. *Courtesy of Kenn Fung.*

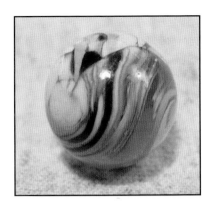

Christensen Agate Company. Guinea, 21/32". Estimate of value: $350 to $700. *Courtesy of Kenn Fung.*

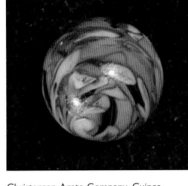

Christensen Agate Company. Guinea, 11/16". Estimate of value: $375 to $750. *Courtesy of Rich Stremme.*

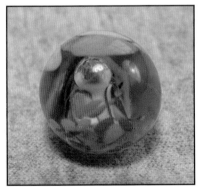

Christensen Agate Company. Guinea ("George Jetson"), 11/16". Estimate of value: $750 to $1,500. *Courtesy of Ken Humphrey.*

Christensen Agate Company. Guinea (backlit), 5/8". Estimate of value: $350 to $700. *Courtesy of Stanley Block.*

Christensen Agate Company. Guinea (backlit), 5/8". Estimate of value: $350 to $700. *Courtesy of Stanley Block.*

Christensen Agate Company 139

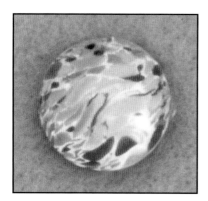

Christensen Agate Company. Guinea (backlit), 5/8". Estimate of value: $350 to $700. *Courtesy of Stanley Block.*

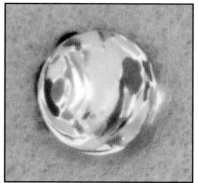

Christensen Agate Company. Guinea (backlit), 5/8". Estimate of value: $350 to $700. *Courtesy of Stanley Block.*

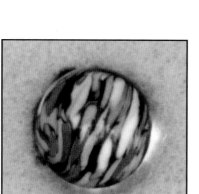

Christensen Agate Company. Guinea (backlit), 5/8". Estimate of value: $350 to $700. *Courtesy of Stanley Block.*

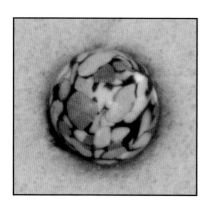

Christensen Agate Company. Guinea (backlit), 5/8". Estimate of value: $350 to $700. *Courtesy of Stanley Block.*

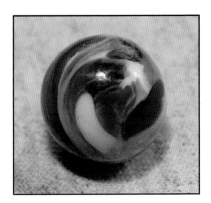

Christensen Agate Company. Guinea (green base), 21/32". Too rare to value. *Courtesy of Steve Smith.*

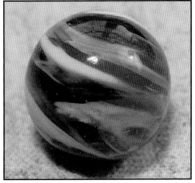

Christensen Agate Company. Guinea (green base), 21/32". Too rare to value. *Courtesy of Steve Smith.*

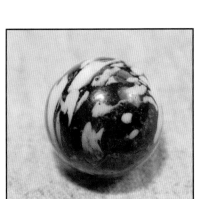

Christensen Agate Company. Guinea (green base), 11/16". Too rare to value. *Courtesy of Hansel de Sousa.*

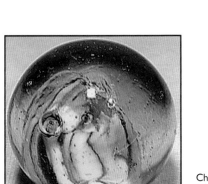

Christensen Agate Company. Guinea. Base appears to be a rust red. 21/32". Too rare to value. *Courtesy of Ray Starkey. (Photo courtesy of Bill Tow.)*

Christensen Agate Company. Guinea/Cobra Hybrid. 19/32". Estimate of value: $1,500 to $3,000. *Courtesy of Bill Tow.*

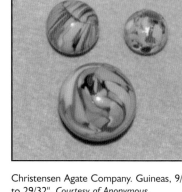

Christensen Agate Company. Guineas, 9/16"
to 29/32". *Courtesy of Anonymous.*

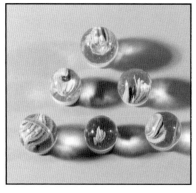

Christensen Agate Company. Guinea/
Cobra hybrids, 9/16" - 19/32".
Courtesy of Stanley Block.

Christensen Agate Company. Cobra, 19/32".
Estimate of value: $600 to $1,200. *Courtesy
of Stanley Block.*

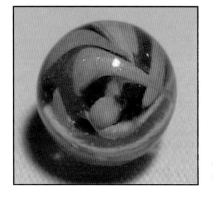

Christensen Agate Company. Cobra, 5/8". Estimate of value:
$600 to $1,200. *Courtesy of Anonymous.*

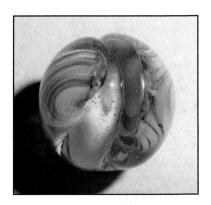

Christensen Agate Company. Cobra, folded in half, 11/16". Estimate of value: $1,000 to $1,800. *Courtesy of Stanley Block.*

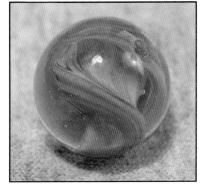

Christensen Agate Company. Cobra, 21/32". Estimate of value: $600 to $1,200. *Courtesy of Bill Tow.*

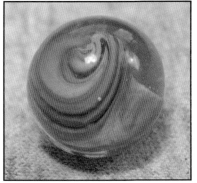

Christensen Agate Company. Cobra, 21/32". Estimate of value: $600 to $1,200. *Courtesy of Bill Tow.*

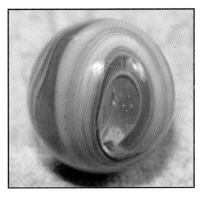

Christensen Agate Company. Cobra, 5/8". Estimate of value: $600 to $1,200. *Courtesy of Bill Tow.*

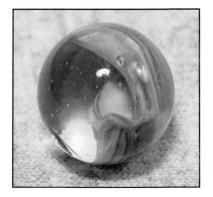

Christensen Agate Company. Cobra, 5/8". Estimate of value: $600 to $1,200. *Courtesy of Bill Tow.*

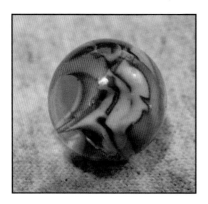

Christensen Agate Company. Cobra, 5/8".
Estimate of value: $600 to $1,200.
Courtesy of Kenn Fung.

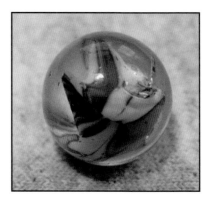

Christensen Agate Company. Cobra, 5/8".
Estimate of value: $600 to $1,200.
Courtesy of Kenn Fung.

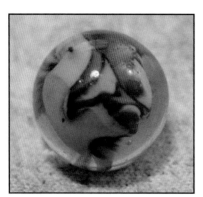

Christensen Agate Company. Cobra, 5/8".
Estimate of value: Too Rare To Value.
Courtesy of Kenn Fung.

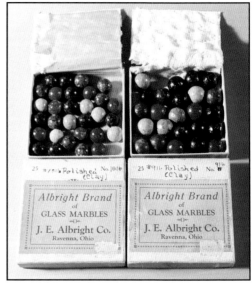

Christensen Agate Company. Box. Albright
Company clays in Christensen Agate Company
boxes, with an Albright label pasted on top.
These boxes were found in the factory building
when it was cleaned out. Estimate of value: Too
Rare To Value. *Courtesy of Stanley Block.*

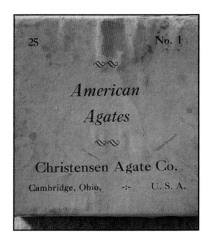

Christensen Agate Company. Box. No. 0
American Agates. Estimate of value: Too Rare To
Value. *Courtesy of Hansel de Sousa.*

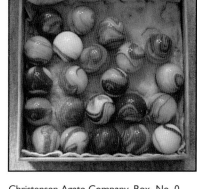

Christensen Agate Company. Box. No. 0
American Agates. Estimate of value: Too
Rare To Value. *Courtesy of Hansel de Sousa.*

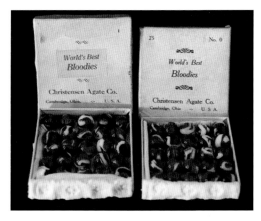

Christensen Agate Company. Box. No. 0 and No. 1
Bloodies. Estimate of value: Too Rare To Value.
Courtesy of Hansel de Sousa.

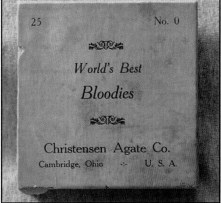

Christensen Agate Company. Box. No. 0 Bloodies.
Estimate of value: Too Rare To Value. *Courtesy of
Hansel de Sousa.*

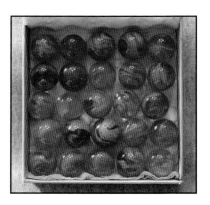

Christensen Agate Company. Box. No. 0
Bloodies. Estimate of value: Too Rare To Value.
Courtesy of Hansel de Sousa.

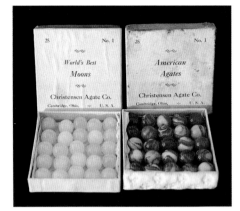

Christensen Agate Company. Box. No. 1 Moons and No. 1 American Agates. Estimate of value: Too Rare To Value. *Courtesy of Hansel de Sousa.*

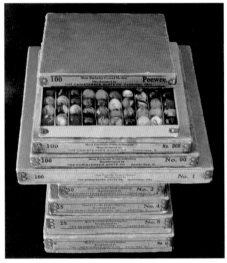

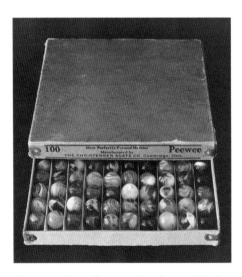

Christensen Agate Company. Box. Assorted. Estimate of value: Too Rare To Value. *Courtesy of Hansel de Sousa.*

Christensen Agate Company. Box. Peewee (slags). Estimate of value: Too Rare To Value. *Courtesy of Hansel de Sousa.*

Christensen Agate Company. Box. No. 000 (slags). Estimate of value: Too Rare To Value. *Courtesy of Robert Sharrer.*

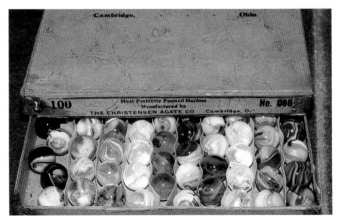

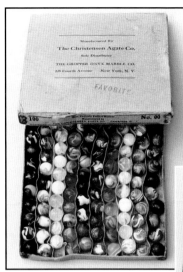

Christensen Agate Company. Box. No. 00 Favorites. Estimate of value: Too Rare To Value. *Courtesy of Stanley Block.*

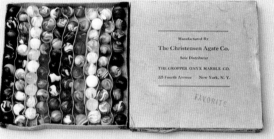

Christensen Agate Company. Box. No. 00 Favorites. Estimate of value: Too Rare To Value. *Courtesy of Stanley Block.*

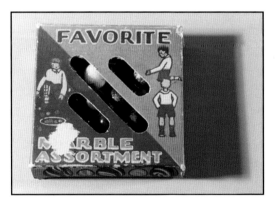

Christensen Agate Company. Box. No. 00 Favorites. Estimate of value: Too Rare To Value. *Courtesy of Block's Box Auctions.*

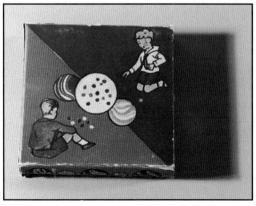

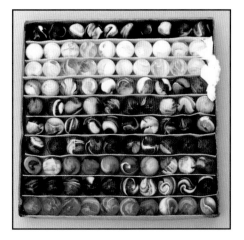

Christensen Agate Company. Box. No. 00
Favorites. Estimate of value: Too Rare To
Value. *Courtesy of Block's Box Auctions.*

Christensen Agate Company. Box. No. 00
Favorites. Estimate of value: Too Rare To Value.
Courtesy of Block's Box Auctions.

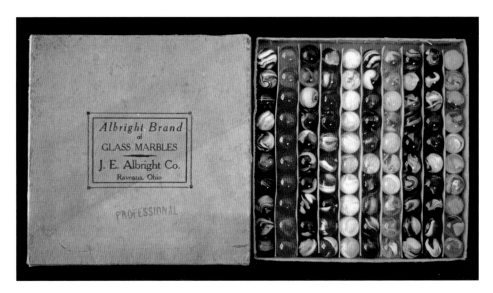

Christensen Agate Company. Box. No. 0 Professional. Estimate of value:
Too Rare To Value. *Courtesy of Hansel de Sousa.*

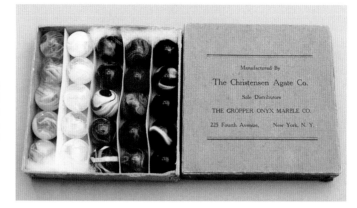

Christensen Agate
Company. Box. No. 4
(slags). Estimate of value:
Too Rare To Value.
Courtesy of Peter Sharrer.

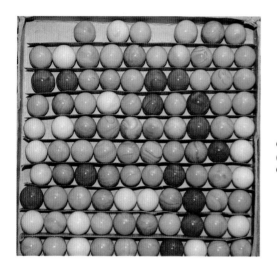

Christensen Agate Company. Box. No. 0
(pastels). Estimate of value: Too Rare To Value.
Courtesy of Pete Caparelli, III.

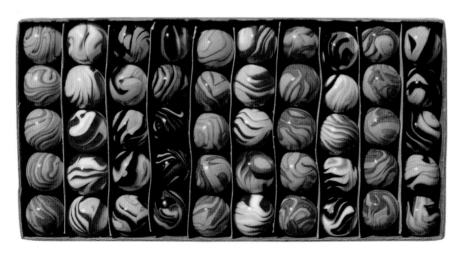

Christensen Agate Company. Box. Swirl Flames. Estimate of
value: Too Rare To Value. *Courtesy of Jim Palko.*

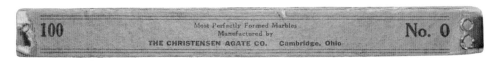

Christensen Agate Company. Box. No. 0 (pastels). Estimate of
value: Too Rare To Value. *Courtesy of Pete Caparelli, Ill.*

Christensen Agate Company. Box. No. 0 (pastels). Estimate of value:
Too Rare To Value. *Courtesy of Pete Caparelli, Ill.*

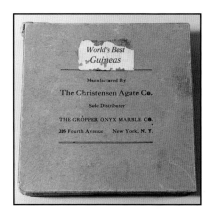

Christensen Agate Company. Box. No. 0 Guineas. Estimate of value: Too Rare To Value. *Courtesy of Stanley Block.*

Christensen Agate Company. Box. No. 1 Guinea. Estimate of value: Too Rare To Value. *Courtesy of Hansel de Sousa.*

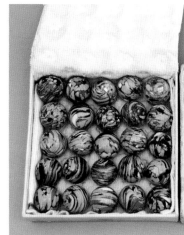

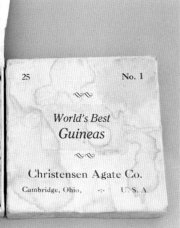

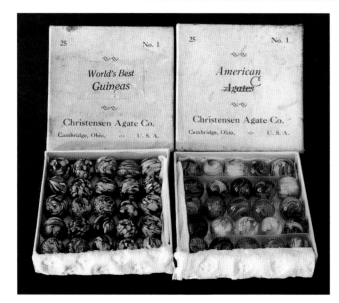

Christensen Agate Company. Box. No. 1 Guinea and No. 1 Cobra. Estimate of value: Too Rare To Value. *Courtesy of Hansel de Sousa.*

Christensen Agate Company 151

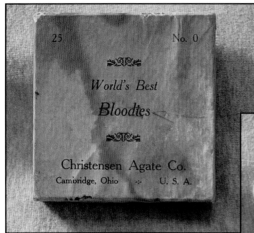

Christensen Agate Company. Box. No. 0 (Cobras). Bloodies box with the name crossed off and a "C" substituted. Speculation is that the "C" stands for Cyclone. Estimate of value: Too Rare To Value. *Courtesy of Hansel de Sousa.*

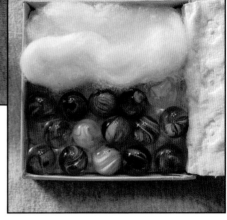

Christensen Agate Company. Box. No. 0 (Cobras). Estimate of value: Too Rare To Value. *Courtesy of Hansel de Sousa.*

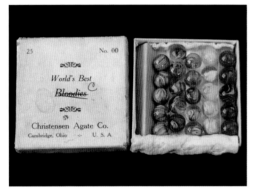

Christensen Agate Company. Box. No. 1 Cobra. Bloodies box with the name crossed off and a "C" substituted. Speculation is that the "C" stands for Cyclone. Estimate of value: Too Rare To Value. *Courtesy of Hansel de Sousa.*

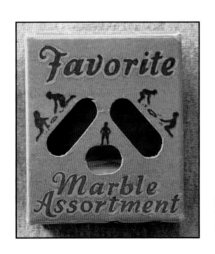

Christensen Agate Company. Box. No. 10 ("C" cutout). Estimate of value: Too Rare To Value. *Courtesy of Hansel de Sousa.*

Christensen Agate Company. Box (front view). Favorite Marble Assortment. Estimate of value: Too Rare To Value. *Courtesy of Hansel de Sousa.*

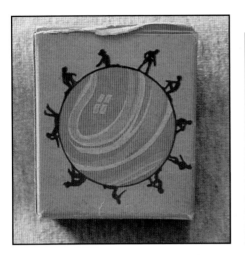

Christensen Agate Company. Box (rear view).
Favorite Marble Assortment. Estimate of value: Too
Rare To Value. *Courtesy of Hansel de Sousa.*

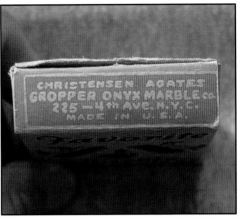

Christensen Agate Company. Box (end flap).
Favorite Marble Assortment. Estimate of value:
Too Rare To Value. *Courtesy of Hansel de Sousa.*

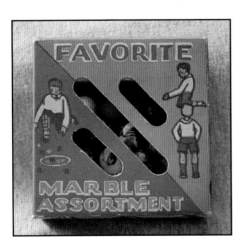

Christensen Agate Company. Box (front view).
Favorite Marble Assortment. Estimate of value: Too
Rare To Value. *Courtesy of Hansel de Sousa.*

Christensen Agate Company. Box (rear view).
Favorite Marble Assortment. Estimate of value: Too
Rare To Value. *Courtesy of Hansel de Sousa.*

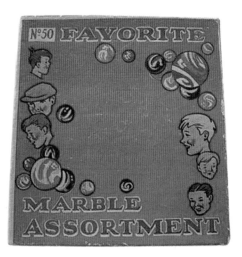

Christensen Agate Company. Box (front view). No. 50 Favorite Marble Assortment. Estimate of value: Too Rare To Value. *Courtesy of Hansel de Sousa.*

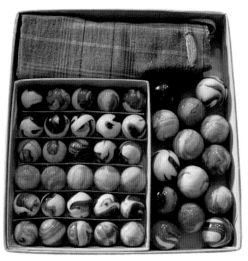

Christensen Agate Company. Box (interior). No. 50 Favorite Marble Assortment. Estimate of value: Too Rare To Value. *Courtesy of Hansel de Sousa.*

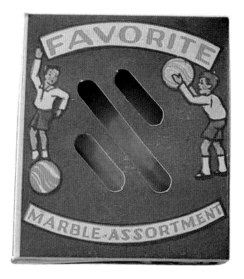

Christensen Agate Company. Box (front view). Favorite Marble Assortment. Estimate of value: Too Rare To Value. *Courtesy of Hansel de Sousa.*

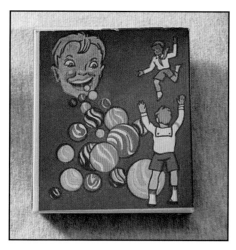

Christensen Agate Company. Box (rear view). Favorite Marble Assortment. Estimate of value: Too Rare To Value. *Courtesy of Hansel de Sousa.*

Christensen Agate Company. Box (fake).
Courtesy of Brian Estepp.

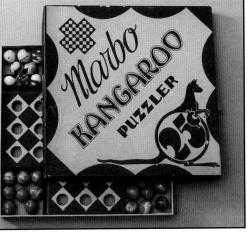

Christensen Agate Company. Game. Estimate of value: Too Rare To Value. *Courtesy of Block's Box Auctions.*

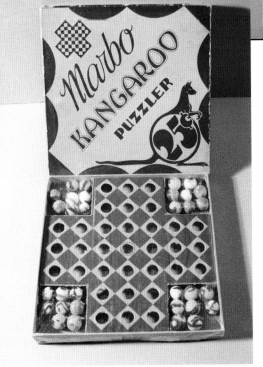

Christensen Agate Company. Game. Estimate of value: Too Rare To Value. *Courtesy of Block's Box Auctions.*

Glossary

AGATE - Quartz type mineral. Preferred by marble players as a shooter for many years. Used as a name by American marble manufacturers to describe their product.

AGGIE - a shooter made from the mineral, agate.

AKRO AGATE COMPANY - Clarksburg WV. Manufactured of machine made glass marbles from about 1915 through 1950.

AKRON STONE MARBLE COMPANY - Boston OH. Manufactured marbles from stone in the mid 1890s.

ALBRIGHT COMPANY, J.E. - Ravenna OH. Manufactured clay marbles from about 1890 through about 1930.

ALLIES - derived from alley tors; prized shooters made of semiprecious minerals.

ALLEY COMPANIES - Lawrence Alley ran a number of companies in West Virginia that manufactured marbles from the 1930s to the 1950s.

ALOX MANUFACTURING COMPANY - St. Louis, MO. Toy manufacturer who also manufactured marbles in the 1940s.

AMERICAN MARBLE & TOY MANUFACTURING COMPANY - Akron OH. Manufactured clay marbles in the 1890s.

ANNEAL - to gradually reduce glass temperature in an oven or Lehr, so as to inhibit cracking in glass.

AVENTURINE - a type of glass containing particles of either copper (goldstone), chromic oxide (green aventurine) or ferric oxide (red aventurine), giving glass a glittering or shimmering appearance.

BATCH - Mixture of various raw materials which when melted yields molten glass.

BUFFED - Term to describe the condition of a marble where the surface has been very lightly polished to remove surface damage or defects.

CAIRO NOVELTY COMPANY - Cairo WV. Produced marbles in the 1950s.

CANE - a long glass rod constructed of layers of different colors.

CARNELIAN - a reddish agate.

CHALKIES - generic term used by marble players to describe unglazed marbles made from clay, limestone or gypsum.

CHAMPION AGATE COMPANY - Pennsboro WV. Manufacturer of machine made glass marbles from the 1940s to the 1990s.

CHIP - the spot where a piece has broken off the surface of a marble, usually from being hit. Small chips are sometimes called "flakes." A barely visible chip is sometimes called a "pinprick" or "pinpoint."

CHRISTENSEN & SON COMPANY, M.F. - Akron OH. First manufacturer of machine made glass marbles. Operated from about 1905 to 1917.

CHRISTENSEN AGATE COMPANY - Cambridge OH. Machine made glass marble manufacturer. Operated in Payne OH from 1925 to 1927, and then in Cambridge OH from 1927-1930.

CLAMBROTH - milk glass marbles in solid color having many thin outer swirl lines of a different color or colors running from pontil to pontil.

CLAY - marbles made of clay which may or may not be colored or glazed.

CLEARIE - clear glass marbles made in a variety of single colors.

CLOUD - an end of day marble where the colored flecks of glass in the marble are not stretched, such that they resemble clouds floating above the core.

COMIC - marbles manufactured by the Peltier Glass Company from 1928 through 1934. They have one of twelve different comic characters stamped and fired onto the marble, such that the transfer is permanent. May also have a transfer of Tom Mix or Cotes Bakery.

COMMIES - term used by marble players to describe marbles made out of clay.

CONTEMPORARY GLASS - a marble handmade by a modern craftsman.

CRYSTAL - very clear, colorless glass.

CULLET - pieces of broken glass that are to be added to a batch.

DAVIS MARBLE WORKS - Pennsboro WV. Manufacturer of machine made glass marbles in the mid 1940s.

DIAMETER - the length of a straight line through the center of a sphere. The size of a marble is measured by its diameter.

DING - the mark left on the surface of the marble by a small blow. The glass on the area damaged is still intact (unlike a chip). This mark is sometimes called a "moon", "subsurface moon" or "bruise."

DIVIDED CORE - swirl-type glass marble having colored bands in the center running from pontil to pontil._

DYKE & COMPANY, S.C. - Akron OH. Manufactured clay and glass marbles in the early 1890s.

EARLY IMPROVEMENT - modification made to Akro Agate machinery that eliminated tiny seam at either end of a machine-made marble and made them smoother. Involved off-setting the rollers on the marble-making machine. Named after an Akro employee, John Early, and implemented around 1927.

END-OF-CANE - a handmade marble that was the first (start-of-cane) or final (last-of-cane) one produced from a cane. These are identifiable as marbles where the internal design ends before one of the pontil marks.

END OF DAY - a handmade glass marble that contains small stretched or unstretched flecks of colored glass that do not run continuously unbroken from pontil to pontil.

FLAKE - shallow area of missing glass on marble surface from striking another marble or hard surface.

FRACTURE - an internal stress line caused by a blow to the surface, chemical stress or thermal stress to the glass. This term also refers to a hairline crack in a sulphide figure caused during manufacture.

FURNACE - a pot, day tank or continuous tank fabricated for melting glass.

GATHER - a portion of molten glass on a punty, sometimes called a glob.

GOB - exact portion of molten glass used to produce a marble

GROPPER ONYX COMPANY - New York City, NY. Distributor of Christensen Agate Company and Peltier Glass Company marbles, usually in boxes with their own name.

HANDMADE - marbles that are made without the use of machines. There usually are cut-off marks (pontil marks) on one or both poles of the marble. A handmade glass marble is made by twisting glass off the end of a glass cane or by gathering glass on the end of a metal rod (punty).

HANDGATHERED - term to describe marbles made from gathering glass at the end of a metal rod (punty).

HEATON AGATE COMPANY - Pennsboro WV. Produced machine made glass marbles from the late 1940s until the early 1930s.

IMMIE - a glass marble streaked with color.

INDIAN - handmade marble consisting of dark base glass with colorful bands applied in the surface or on top of it from pontil to pontil.

IOWA CITY FLINT GLASS MANUFAC-TURING COMPANY - Iowa City IA. Produced handmade marbles in the early 1880s.

JABO COMPANIES - Pennsboro WV. Variety of glass machine made marble companyies operated by the Bogard family from the 1940s until the present time

JACKSON MARBLE COMPANY - Pennsboro WV. Manufacturer of machine made glass marbles in the mid 1940s.

LATTICINIO - a swirl-type glass marble with thin strands in the center running from pontil to pontil that form a net when the marble was twisted.

LEHR - an annealing furnace or oven.

LUTZ - handmade glass marbles that contain finely ground goldstone.

MACHINE-MADE - a marble that is made by machines. Generally, they are perfectly round and have no pontil marks. These marbles were made after 1900, predominately in the United States.

MANUFACTURING DEFECT - a fold, crease, additional melted glass or open air bubble on the surface of a marble, or a hairline fractures in sulphide figures.

MARBLE KING - Paden City WV. Founded by Berry Pink. Manufacturer of machine made glass marbles from the 1950s until the present.

MASTER MARBLE COMPANY & MASTER GLASS COMPANY - Clarksburg WV. Manufacturer of machine made glass marbles from the 1930s to the 1970s.

MIBS - the game of marbles, from a shortening of the word marbles.

MICA - mineral silicates that occur in thin sheets and are reflective or silvery in appearance. Coarsely ground flakes of mica are sometimes placed in handmade marbles. The German name is "glimmer".

MILKIES - translucent white glassies.

NAVARRE GLASS AND SPECIALTY COM-PANY - Navarre OH. Manufactured glass marbles in the early 1900s.

ONIONSKIN - an end of day marble where

the colored flecks of glass are stretched, such that the core resembles the skin of an onion.

ONYX - name for slag type marbles.

OPAQUE - a handmade or machine-made marble that is a single color and that is so dark that light does not shine through it.

PEE WEE - a marble that is 1/2" or less in diameter.

PELTIER GLASS COMPANY - Ottawa IL. Manufacturer of machine made glass marbles from the 1920s to the present.

PEPPERMINT - a handmade swirl marble that has bands of red, white and blue under the surface.

PINPRICK - Damage or defect on the surface of a marble that is about the size of the point of a pin.

PIT - Damage or defect on the surface of a marble that is slightly larger than a pinprick.

PLAYRITE MARBLE AND NOVELTY COMPANY -Lamberton WV. Manufacturer of machine made glass marbles in the mid 1940s.

POLISHED - work which has been done to the surface of a marble to make it more presentable by clearing up cloudiness, surface roughness, scratches or small chips. A polished handmade marble no longer has pontils. A polished machine-made marble is missing the top layer of glass. A handmade marble that has been polished, but that still has its pontils is referred to as "buffed." A machine-made marble that still retains some of its original surface is also referred to by the same name.

PONTIL - a rough mark left on the pole of a marble where it was sheared off a rod or the end of a punty.

PUNTY - a long solid metal rod used to hold a glass object that is being made.

PURIE - a small, brightly colored Clearie.

Ravenswood Novelty Company - Ravenswood WV. Manufacturer of machine made glass marbles from the 1930s to the 1950s.

RIBBON CORE - a handmade swirl with a single or two flat bands in the center running from pontil to pontil.

SHOOTER - the marble used to aim at and strike other marbles in a game. Regulation size is 1/2" to 3/4".

SINGLE GATHER - a marble that was made completely on the end of a punty and not from a cane.

SINGLE PONTIL - a marble with only one pontil, created from either the end of cane or single gathered.

SLAG - a marble made from two different colors of glass that were melted together in the same furnace pot. Due to the differing densities of the glass, they would not melt into a homogeneous color. Handmade slags have pontils. Machine-made slags consist of a colored transparent glass with opaque white swirls.

SOLID CORE - a handmade swirl with a series of bands in the center running from pontil to pontil that are spaced so closely together that no clear space remains between each band.

SPARKLE - subsurface damage to a marble caused by light contact with another marble or hard surface. Not completely round, as a subsurface moon. No glass missing.

STEELIE - a marble made out of steel that can be either solid or hollow.

STRIAE - elongated imperfections in glass caused by temperature differences or unequal density of the materials used. Striae are not fractures.

SUBSURFACE MOON - Subsurface damage to a marble from contact with another marble or hard surface. Produces a circular defect on the marble, but no glass is missing.

SULPHIDE - objects made of china clay and supersilicate of potash that are inserted into a transparent glass sphere.

SWIRL - either a handmade marble with bands or strands running continuously unbroken from pontil to pontil, or a machine-made marble that is manufactured by injecting one or more colors into a base stream of glass.

TARGET - the marble in a game that was shot at by the shooter. Tournament regulations set the size at 5/8".

TAW - derived from alleytor; a prized shooter made of semiprecious stone, usually agate.

TRANSITIONAL - name given by early marble authors to describe single pontil slags, and similar marbles. Originally, it was postulated that these represented the bridge between handmade and machine made marbles. We now know they are caused by a number of different processes.

VACOR DE MEXICO - Mexico. Manufacturer of marbles from the 1930s to the present. Currently, the largest producer of marbles in the world.

VITRO AGATE COMPANY - Parkersburg WV. Manufacturer of machine made glass marbles in Parkersburg WV and Anacortes WA from the 1930s until the 1990s. Merged with Jabo Company.

Bibliography

Allen, Shirley "Windy." *The Game of Marbles.* Marble King Inc., 1975.

Barrett, Marilyn. *Aggies, Immies, Shooters and Swirls: The Magical World of Marbles.* Boston: Little, Brown and Company, 1994.

Baumann, Paul. *Collecting Antique Marbles.* Wallace-Homestead Book Co., 1994.

Block, Mark. *Contemporary Marbles and Related Art Glass.* Schiffer Publishing, 2000

Block, Robert. *Marbles: Identification and Price Guide.* Schiffer Publishing, 2002.

_____. *Marbles Illustrated.* Schiffer Publishing, 1999.

_____. *Pictorial Guide to Marbles.* Schiffer Publishing, 2002.

Block, Stanley. "Marbles-Playing for Fun and for Keeps." *The Encyclopedia of Collectibles - Lalique to Marbles.* Time-Life Publications, 1983.

_____, editor. *Marble Mania.* Schiffer Publishing, 1999

_____. *Antique Sulphide Marbles.* Schiffer Publishing, 2000.

_____. *Antique Swirl Marbles.* Schiffer Publishing, 2001.

_____. *Antique End of Day Marbles.* Schiffer Publishing, 2002.

Boy Scouts of America. *Cub Scout Sports: Marbles.* 1984.

Carskadden, Jeff, and Richard Gartley. *Chinas: Hand-painted Marbles of the Late 19th Century.* McClain Printing Co., 1990.

Carskadden, Jeff, and Mark Randall. "The Christensen Agate Company, Cambridge, Ohio (1927-1933)." *Muskingum Annals,* Volume 4, 1987.

Castle, Larry, and Marlowe Peterson. *The Guide to Machine-Made Marbles.* Utah Marble Connection, Inc., 1992.

Chevat, Richard. *The Marble Book.* Workman Publishing Company. 1996.

Degenhart Paperweight & Glass Museum. *Reflection, Guernsey County Glass - 1883-1987.* Self-published, 1989.

Dickson, Paul. "Marbles." *Smithsonian,* April 1988.

Ferretti, Fred. *The Great American Marble Book.* Workman Press, 1983.

Grist, Everett. *Antique & Collectible Marbles.* Collector Books, 1992.

_____. *Big Book of Marbles.* Collector Books, 1994.

_____. *Machine-Made and Contemporary Marbles.* 1995.

Hardy, Roger, and Claudia Hardy. *The Complete Line of Akro Agate.* Self-published.

http://www.marblecollecting.com

http://www.akronmarbles.com

Ingram, Clara. *The Collectors Encyclopedia of Antique Marbles.* Collector Books, 1972.

Levine, Shar. *A Marble Players Guide.* Sterling Publications. 1998.

Marble Collectors' Society of America. *Marble-Mania.* Quarterly newsletter. Published since 1976.

Marble Collectors' Society of America. *Price Guide.* Self-published, 1989.

Morrison, Mel, and Carl Terrison. *Marbles - Identification and Price Guide.* Self-published, 1968.

Randall, Mark. *Marbles as Historical Artifacts.* Marble Collectors' Society of America, 1979.

Runyon, Cathy. *Knuckles Down! A Guide to Marble Play.* Right Brain Publishing Co., 1985.

Stanley, Mary Louise. *A Century of Glass Toys.* Forward's Color Productions, date unknown, early 1970s.

Taber, Ed. *The Klutz Book of Marbles.* Klutz Press, 1989.

Webb, Dennis. *Greenberg's Guide to Marbles.* Greenberg Publishing Co., Second Edition, 1994.

Note on Estimates of Values

The estimates of value shown with each marble are meant as guidelines only. Many of the marbles in this book are rare and mint. The value of premium examples is always volatile. Caution should be exercised in applying values to actual examples. Consult *Marbles: Identification and Price Guide* by this author for more detailed information on marble pricing.

Notes